THE FINE ART OF
KIMONO
EMBROIDERY

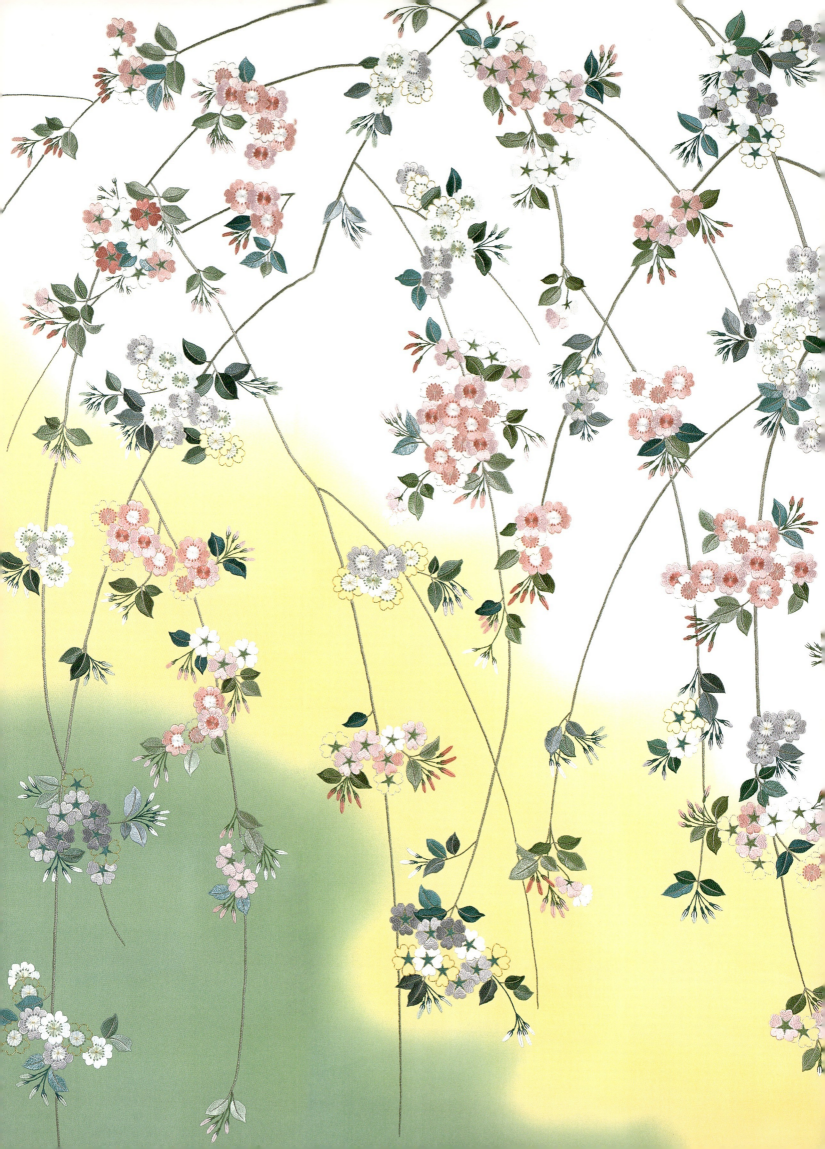

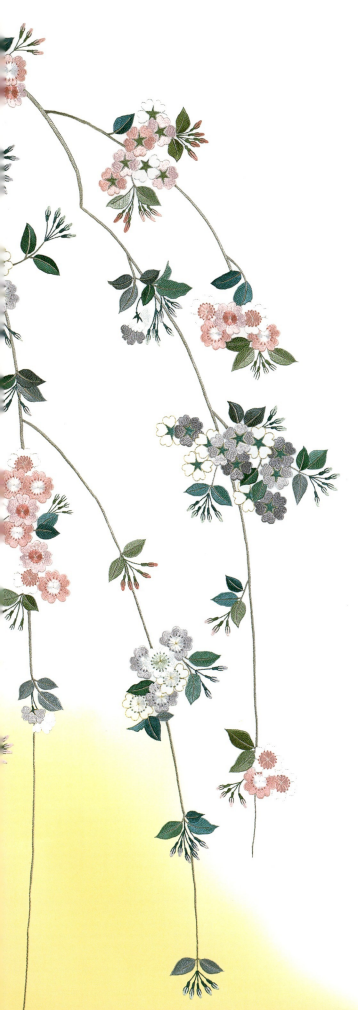

THE FINE ART OF KIMONO EMBROIDERY

Shizuka Kusano

PHOTOGRAPHS Masayuki Tsutsui

TRANSLATION Gavin Frew

KODANSHA INTERNATIONAL
Tokyo · New York · London

NOTE: Names of Japanese people from the pre-modern era are written in the Japanese style with family name first, given name second; those dating post-1868 are written in the Western style with given name first, family name second.

Jacket photograph: *Inochi no inori* ("The Prayer of Life").
Back jacket photograph: *Hana utsuroi* ("Transient Flowers").
Half-title page photograph: a design by the author; the outline of the design is first stitched in white thread.
Photograph on pages 2–3: *Haru no yume* ("Dreams in Spring").
Photographs on pages 4 and 5: contrasting motifs of cherry blossoms.
Photograph on pages 6–7: detail from *Kurimuto ni sasageru nonohana* ("Wild Flowers Dedicated to Klimt").

The publisher wishes to thank Ginny Tapley for her skillful editing.

Distributed in the United States by Kodansha America, Inc., and in the United Kingdom and continental Europe by Kodansha Europe Ltd.

Published by Kodansha International Ltd., 17–14 Otowa 1-chome, Bunkyo-ku, Tokyo 112–8652, and Kodansha America, Inc.

Copyright © 2006 by Shizuka Kusano.
Photographs copyright © 2006 by Masayuki Tsutsui.
All rights reserved. Printed in Japan.
ISBN978-4-7700-3024-5

First edition, 2006
15 14 13 12 11 10 09 08 07 10 9 8 7 6 5 4 3 2

www.kodansha-intl.com

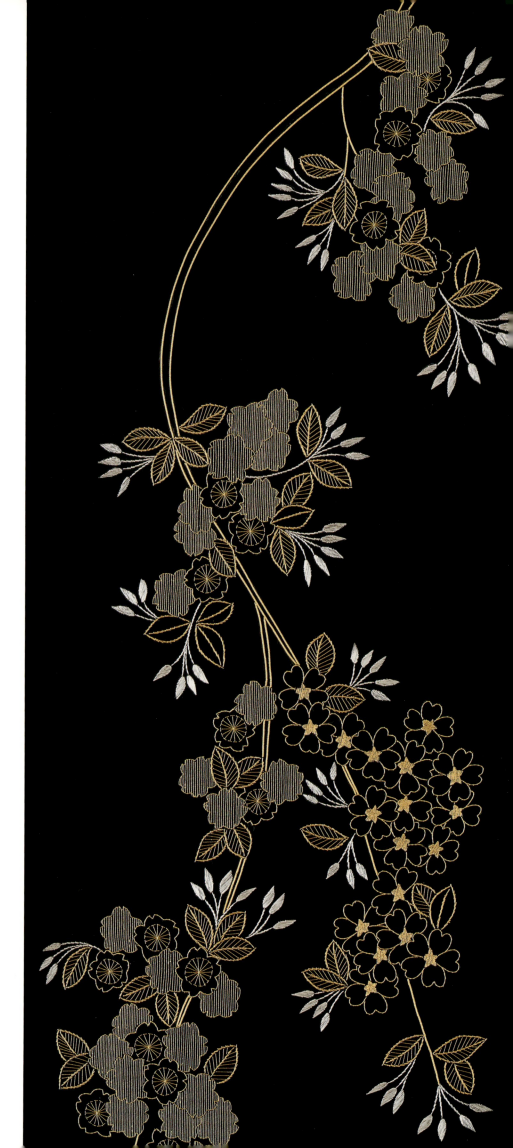

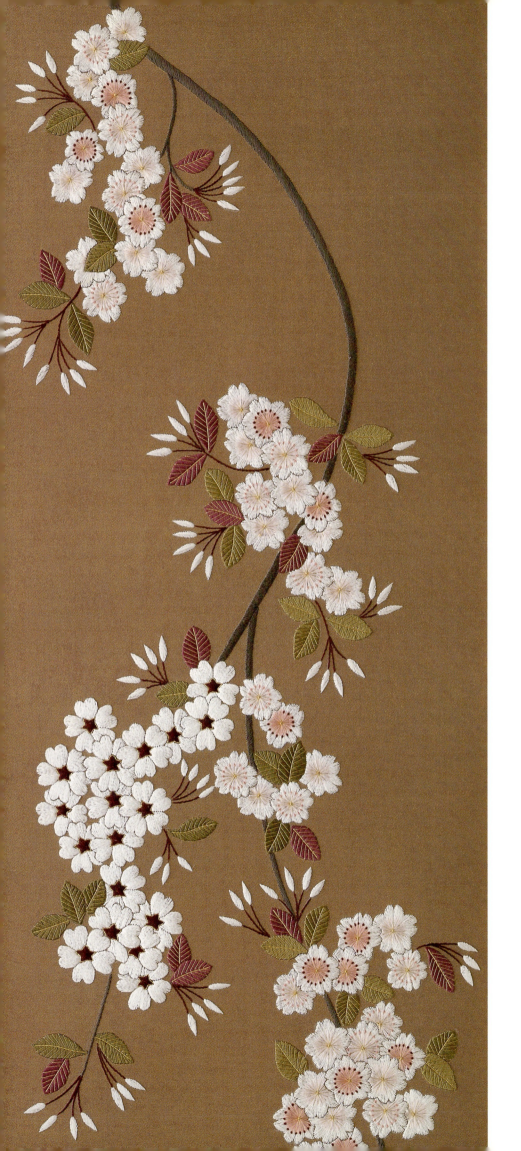

CONTENTS

Introduction 6

Embroidered Works
 Kimono 8
 Kimono and Obi 36
 Obi 54
 Tapestries 80

The History of Japanese 90
 Embroidery

My First Encounters 96
 with Embroidery

Technical Notes and Glossary 103

Acknowledgments 110

Introduction

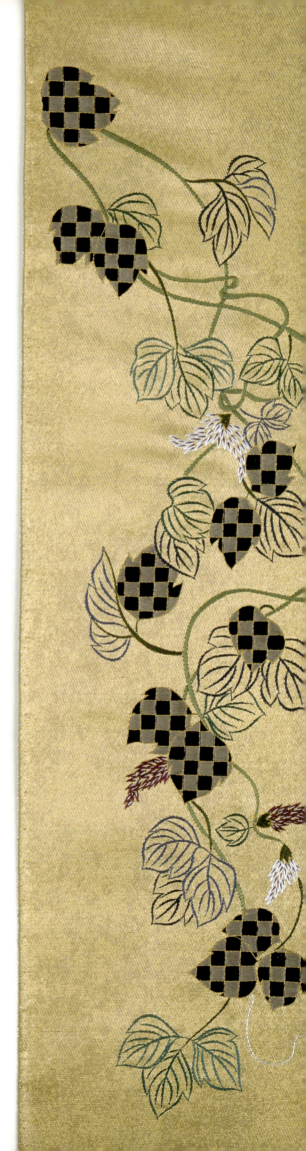

It seems hard to believe that over forty years have passed since I first started embroidery. I became obsessed by Japanese embroidery, devoting myself to the creation of new works while simultaneously being blessed with the chance to show these to large numbers of people. This book represents the culmination of my career, while also fulfilling a personal wish to create an opportunity for as many people as possible to come into contact with my kind of Japanese embroidery.

I would also like to take this chance to try to answer a question with which I am so often confronted, "What is Japanese embroidery?" and to offer my personal views on the subject.

We all have a certain image of what is meant by "Japanese embroidery," but it is difficult to come up with a clear definition of the term. In an effort to overcome this, I decided to split the subject into its two composite parts, namely technique and design. To begin with technique, I believe there is very little difference between Japanese embroidery and that produced in the rest of the world. Embroidery is essentially the art of creating decoration using fabric and threads: this is true everywhere and although there may be slight variations in the types of fabric and threads used, there are no major differences. I have occasion to teach embroidery to foreigners and although the names of the stitches, such as *suganui* or *sagaranui*, may be uniquely Japanese, there is invariably an English term to describe the same technique. I therefore think that the techniques of traditional embroidery vary little wherever they may be practiced.

This being said, although the basic techniques may not differ, the combination of materials used to achieve particular results is an area in which Japanese embroidery has clear characteristics of its own. To be more precise, Japanese embroidery utilizes silk threads on silk fabrics, or combines embroidery with *shibori* (tie-dye) or *haku* (silver or gold leaf) to create unique results. These techniques of utilizing the luster and softness of silk threads or using *shibori* or *haku* to heighten the decorative effect began with the development of Nō drama costumes and the adoption of the *kosode* (original form of kimono) as the universal style of dress, regardless of status, from the sixteenth to seventeenth centuries.

With regard to design, there are no particular motifs unique to embroidery in Japan—the genre simply shares those used by the Japanese textile industry as a whole. It can be said, however, that it is the motifs that make Japanese embroidery so "Japanese," but this brings us to the question of what kind of subject can be considered Japanese. I think that if you were to ask any Japanese person, they would mention cherry blossoms, maple leaves, or autumnal grasses. Research into traditional Japanese motifs shows that after the *kosode* garment was generally adopted during the seventeenth century, a rich variety of motifs based on nature, annual ceremonies, and festivals was developed. Of course, as in other countries geometric, astronomical, and animal designs were also used, but by far the most numerous and refined were those based on flowers, birds, and scenery of the four seasons.

A fascination with the changing of the seasons has always been a major feature of Japanese culture and it remains so today. For instance, the blooming of that quintessential spring flower, the cherry blossom, is so eagerly awaited that the meteorological office uses a supercomputer to calculate when the trees will bloom in particular areas, then produces maps to show how this will progress across the country. People refer to these maps to plan their trips to go cherry blossom viewing, and in much the same way they enjoy the colors of the leaves in autumn. This love of the seasons is reflected in our clothing, food, and housing, and is an important aspect of Japanese life.

Of course, Japan is not the only country to experience four clearly defined seasons, but I think that what is unusual is the way in which the people appear more aware of this natural phenomenon of the changing seasons, even sublimating it into their national culture.

Ultimately, it can be said that Japanese embroidery sprang from this sensitivity to nature, utilizing motifs fostered by the environment in its designs. The reason I am so interested in Japanese traditional motifs and embroidery, and eager to study the subject in earnest, is that I want to nurture this Japanese sensitivity and aesthetic within me while simultaneously making it a part of my work.

In this book I will introduce the various processes through which my work is created. Sometimes old kimono or obi (sashes) have inspired me to produce new works, existing patterns may stimulate me to enhance them through embroidery, or I might create a work entirely from scratch, ordering the fabric with the woven pattern I desire and having it dyed to my specifications before adding the embroidery.

After the kimono has been put on, the obi is wrapped around the waist then tied with a large bow or fold at the rear. The obi is designed so that when it has been fastened, the main feature of the design comes in the center of the bow or fold. The color and style of the obi is chosen to coordinate with the kimono, so in order to allow the viewer to appreciate the way in which they complement each other, I have included photos depicting the obi together with the kimono.

I will be extremely happy if this book enables readers around the world to catch a glimpse of the world of Japanese embroidery and traditional kimono.

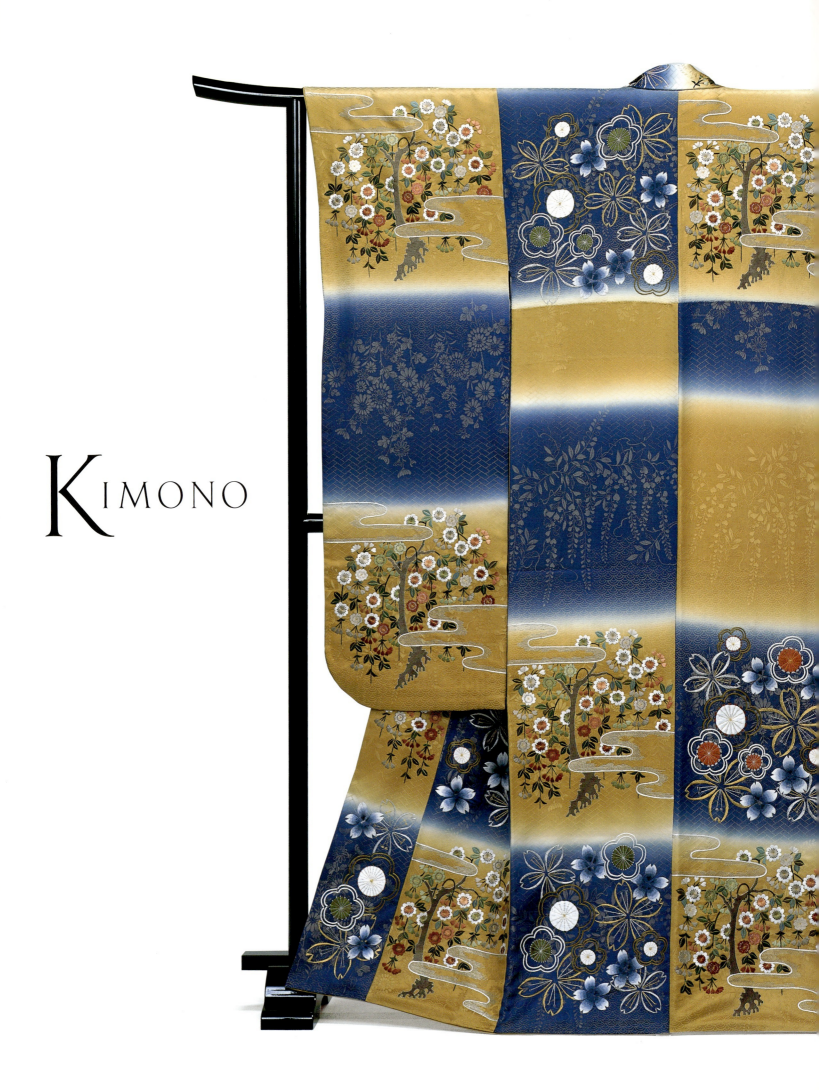

KIMONO

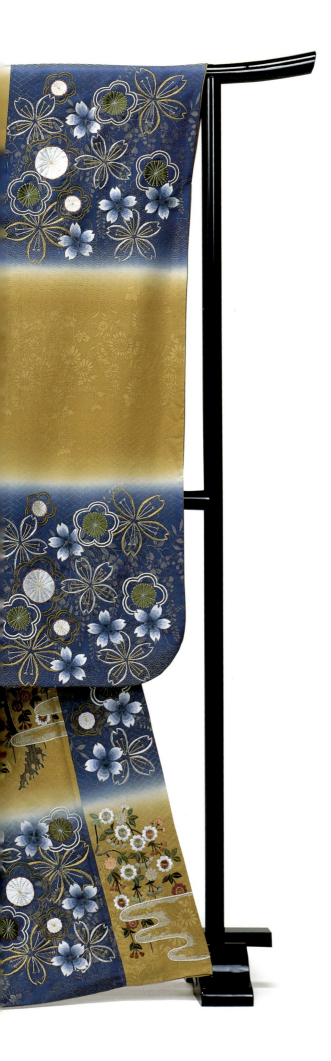
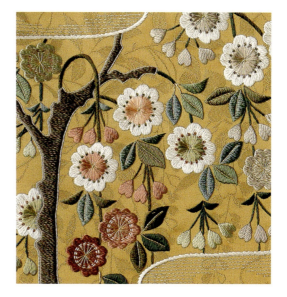
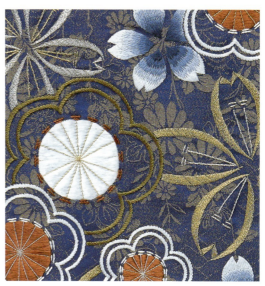

Saigyō zakura
Saigyō's Cherry Tree

Zeami Motokiyo (1363–1443) is recognized as the founder of Nō drama and *Saigyō zakura* is the title of one of his most famous plays. The main character is Saigyō, a priest renowned for his poems about cherry blossoms. There is a large cherry tree in his garden that blooms magnificently in the spring, attracting large numbers of people who come to celebrate its beauty. Saigyō regrets this as he wishes to converse quietly with the tree. One night the spirit of the tree speaks to him in a dream: "I am what I am and bloom quite naturally." Hearing this, Saigyō realizes how small-minded he has been, and from that day onward he is able to experience the cherry blossoms quietly in his heart regardless of whether other people are present or not.

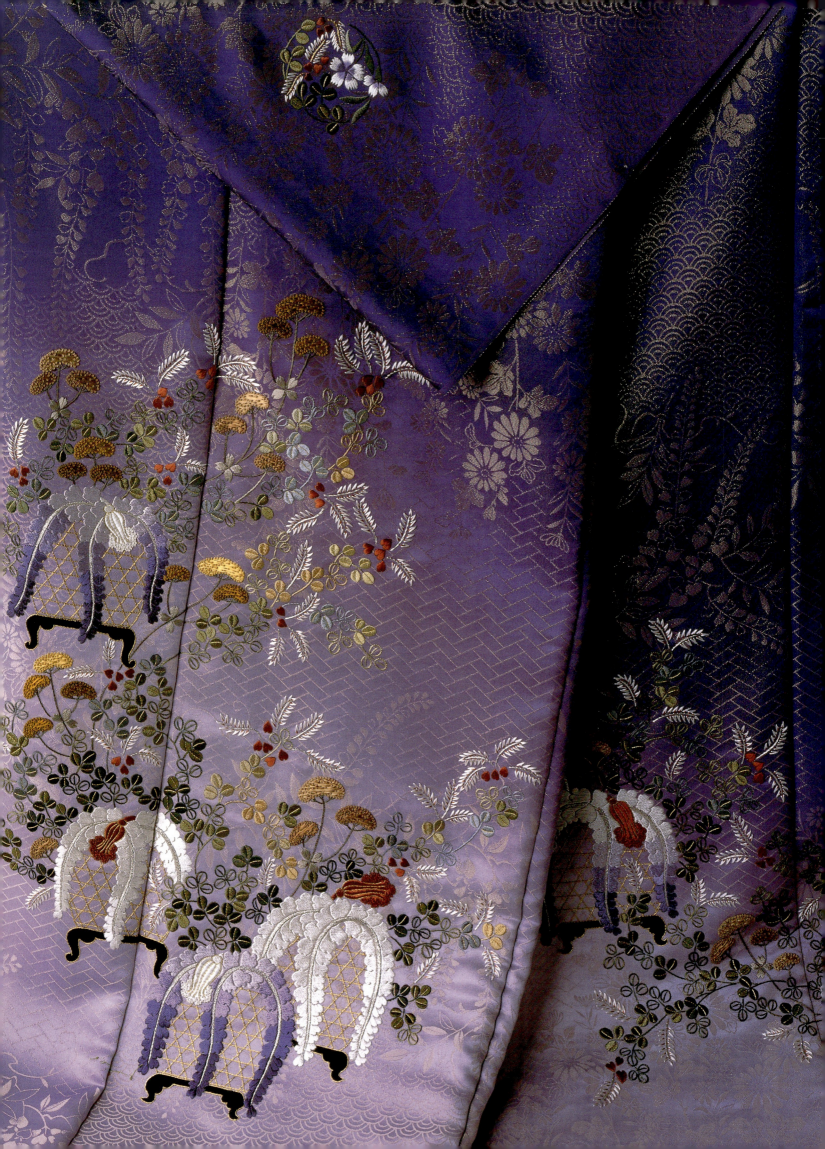

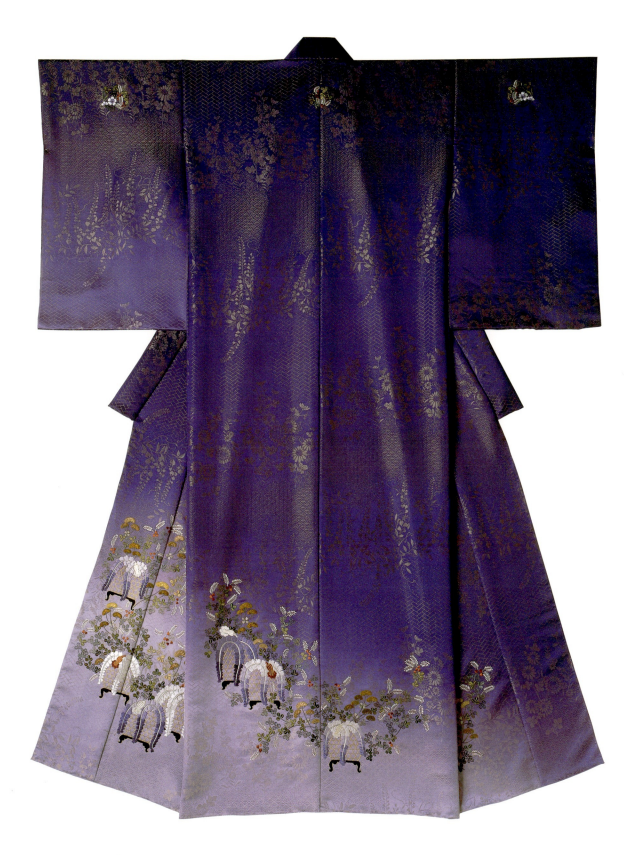

ARU ONNA
A Certain Woman

This motif expresses the love of Yōko, the heroine in Takeo Arishima's (1878–1923) famous novel, *Aru onna*. Having broken up with her fiancé, Yōko falls in love with a man called Kuraji, but no matter how much love she offers him she never finds satisfaction and her loneliness only deepens. The mauve dye of the fabric symbolizes the melancholy experienced by the heroine, while the bush clover, whose blossom can withstand both wind and snow, represents her desire to live life her own way no matter how painful it may be.

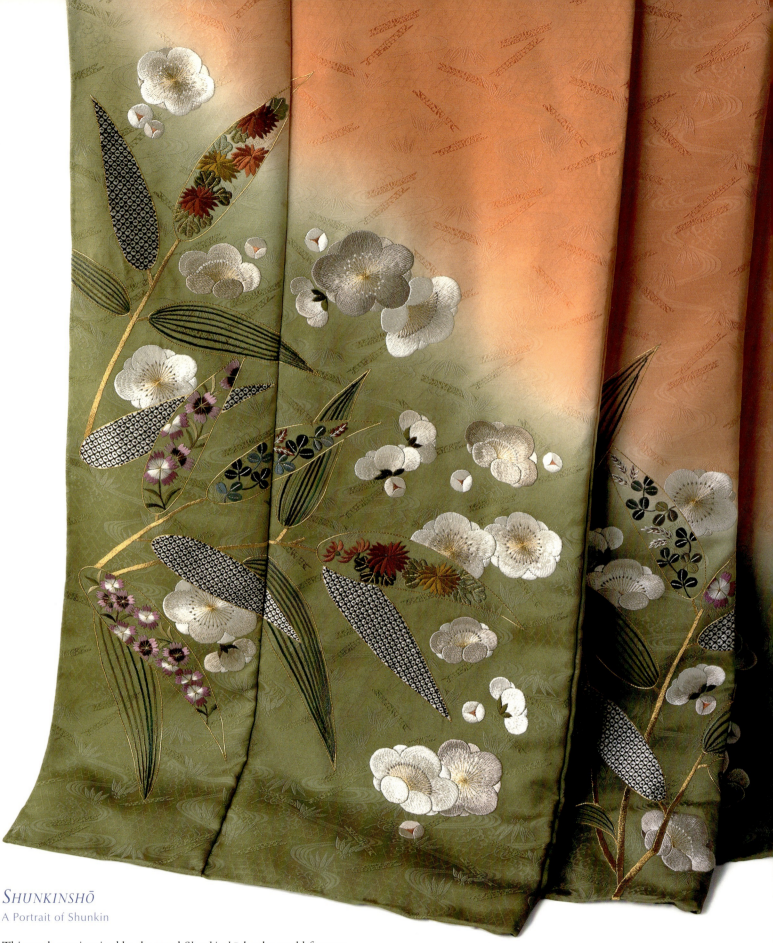

Shunkinshō
A Portrait of Shunkin

This work was inspired by the novel *Shunkinshō*, by the world-famous Japanese writer Jun'ichirō Tanizaki (1886–1965). This is a love story about a beautiful blind girl named Shunkin and a servant employed by her family, Sasuke. Through her love for Sasuke, the ingenuous yet haughty Shunkin awakens to the charms and emotions of a grown woman. In this kimono I have expressed the character of Shunkin through the scent of the plum blossoms that bloom selfishly here and there, while Sasuke, who is at the mercy of Shunkin's whims, is represented by the bamboo leaves.

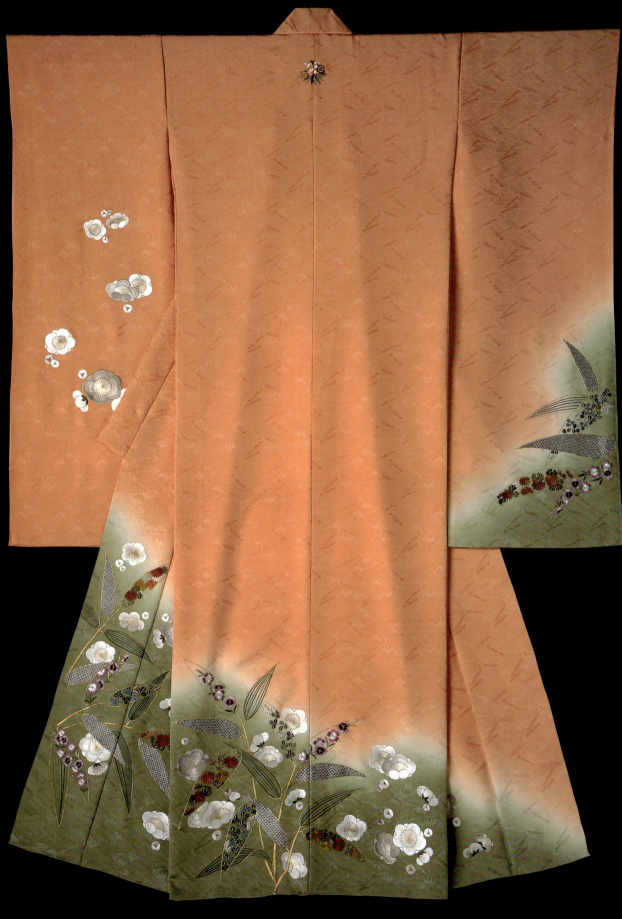

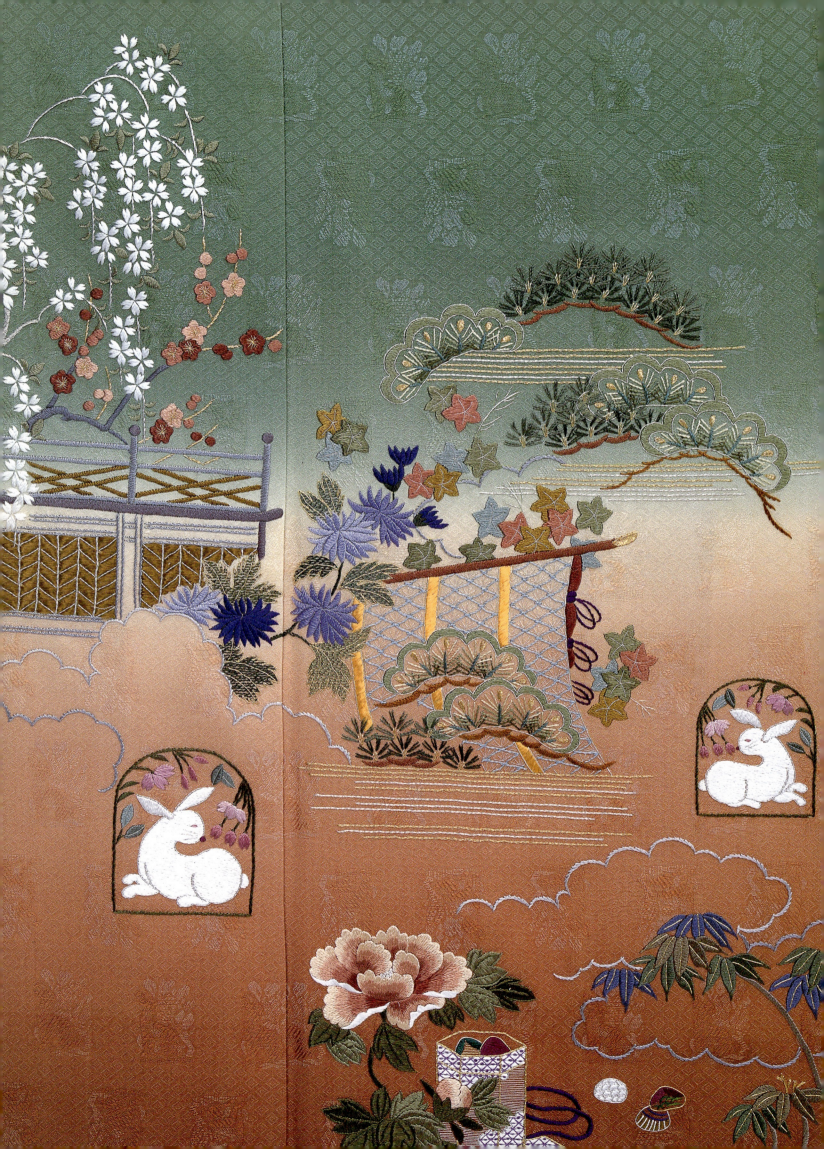

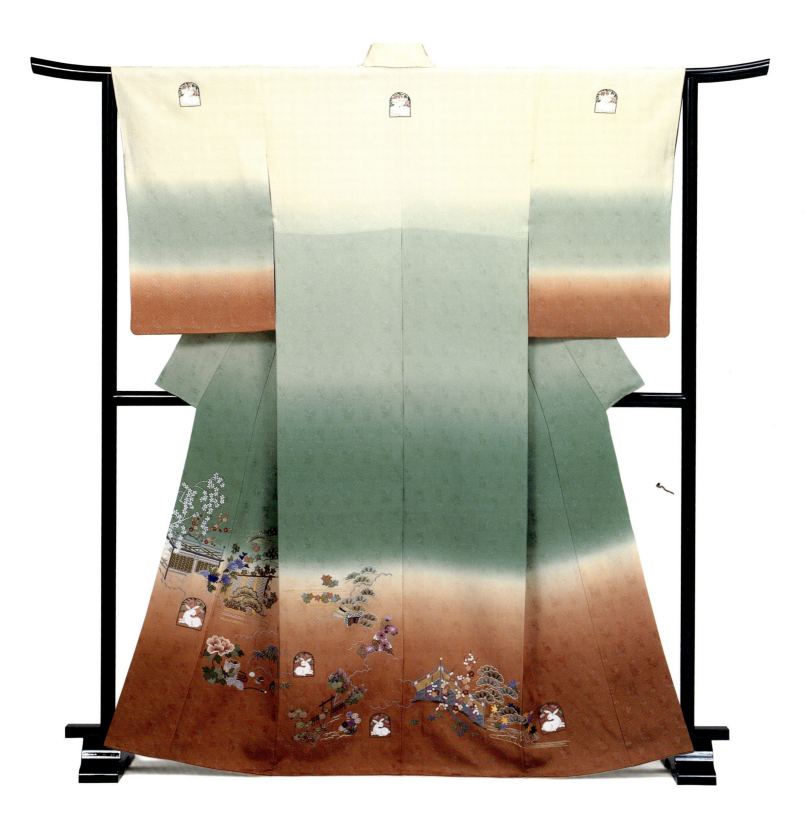

ONNA SANNOMIYA

This motif is taken from *The Tale of Genji*. Onna Sannomiya was lovingly raised by her father, the emperor, and was later married to Prince Genji, a man twenty-five or twenty-six years her senior. She was so small and cute that she appeared to be dwarfed by her robes, and her mind was forever filled with reminiscences of her childhood. This image of her has been expressed through the caged rabbit.

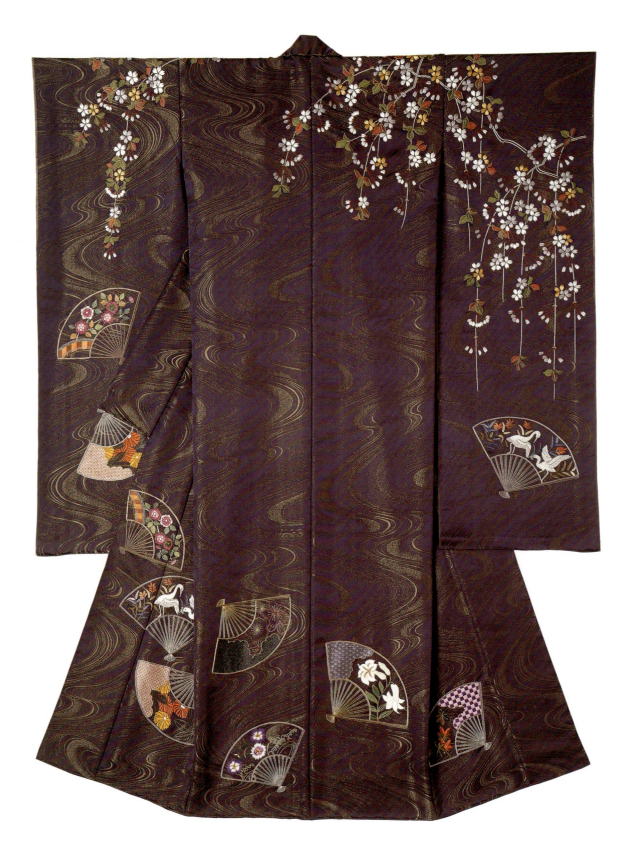

SAKURA NO MAI
Cherry Blossom Dance

This kind of long-sleeved kimono is worn by young women for the coming-of-age ceremony, weddings, and other special occasions. The weeping cherry blossoms decorating the upper chest and sleeve represent the pliancy of women, while the pattern of fans at the bottom is suggestive of their dancing form. The surfaces of the fans have been decorated with various designs taken from Nō costumes, imbuing the garment with a sense of distinction.

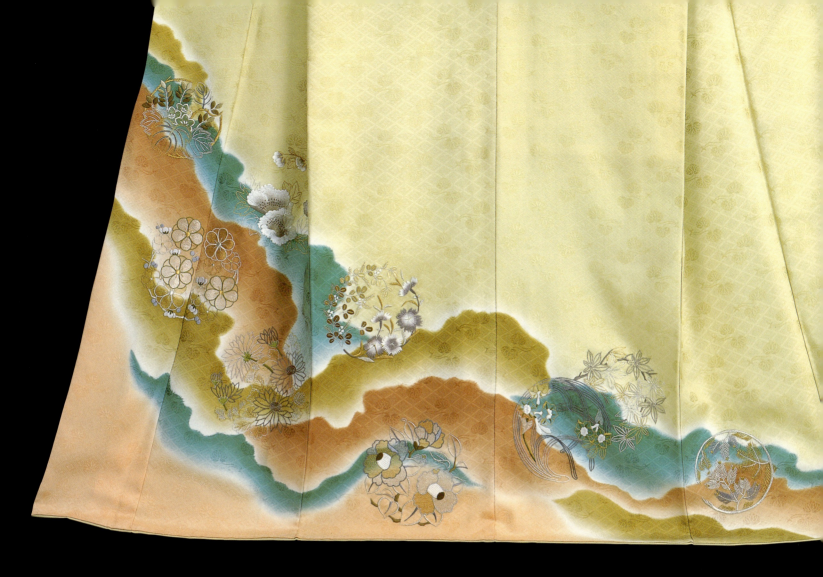

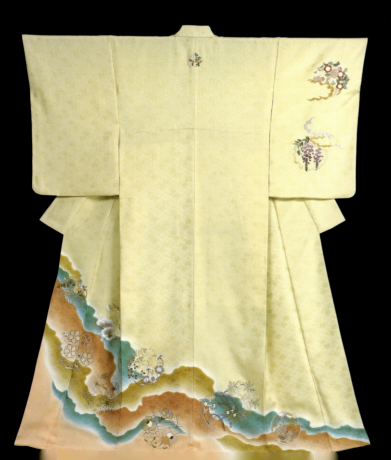

Yūgiri

This work is based on chapter thirty-eight of *The Tale of Genji*. Yūgiri was the son of Prince Genji and Lady Aoi no Ue. He married Kumoi no Kari, who enjoyed her husband's love and was extremely happy, but later he fell for another woman and life became hard for her. The circular floral designs of seasonal flowers symbolize the passage of time.

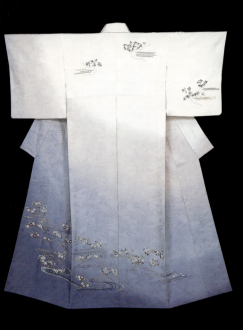

Hana no En
The Flower Feast

This work is from chapter eight of *The Tale of Genji*, based on the concept of a fan with a design of flowing water and hazy moon on a pink background. Prince Genji searches for a woman with whom he had spent a single night, but the only clue he has to her identity is her fan. The owner of this fan turns out to be his brother's consort, Oborozukiyo.

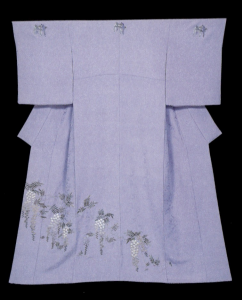

Sakaki
The Sacred Tree

This is from chapter ten of *The Tale of Genji*. Genji risked his life for his love of his stepmother, Fujitsubo, who was married to his father, the emperor. Unable to refuse him, she became a nun to atone for her sin and escape from Genji's love.

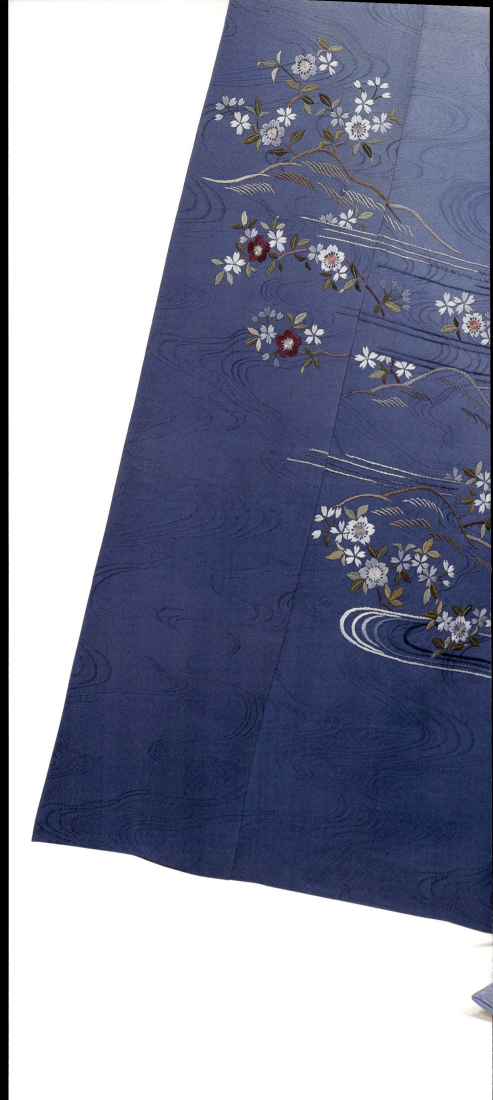

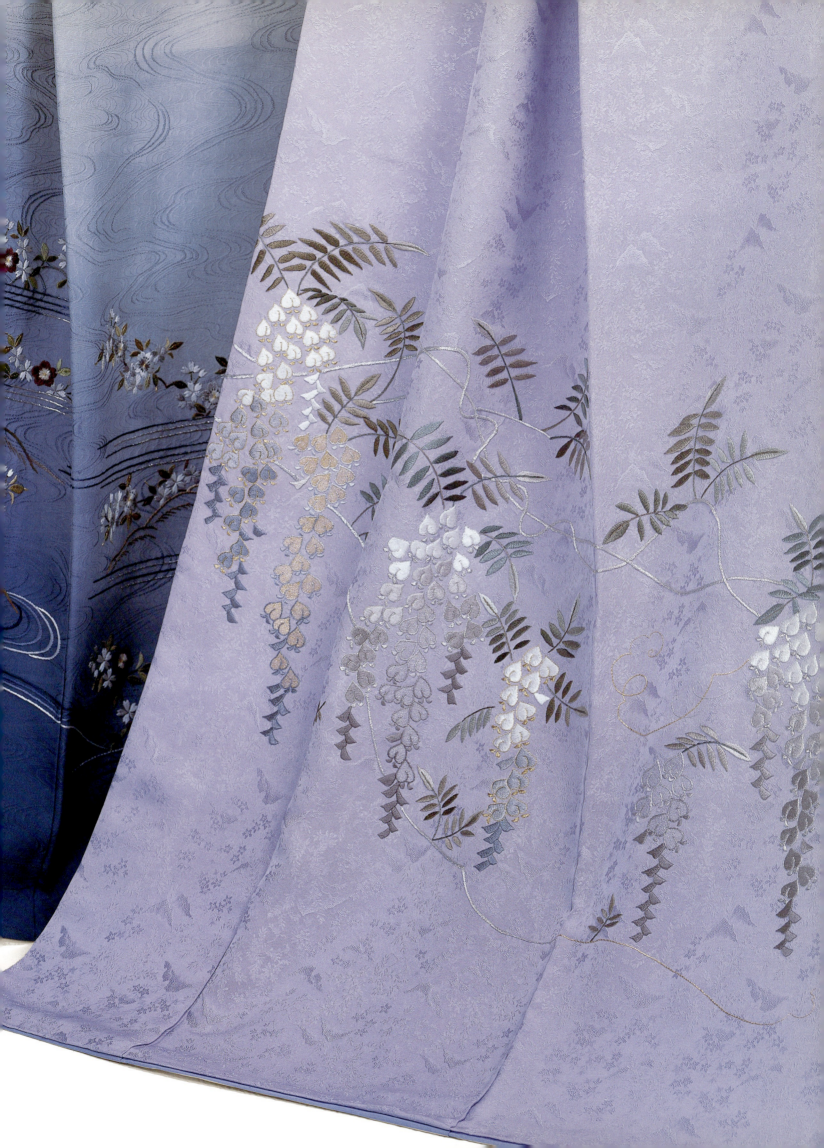

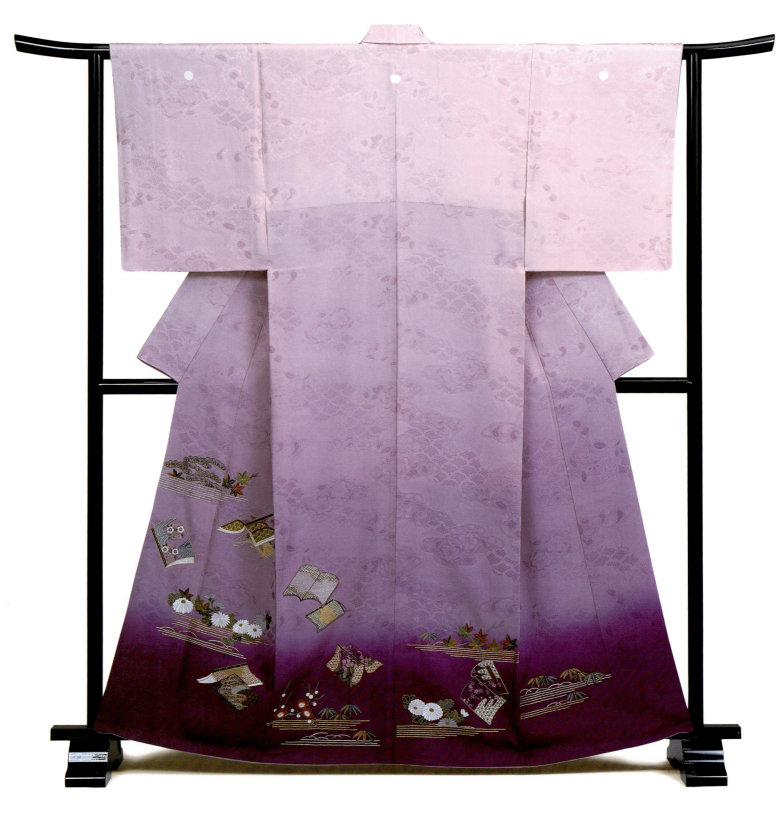

MURASAKI

In chapter five of *The Tale of Genji*, Genji swore undying love for Fujitsubo, his own stepmother. However, one day he spies a beautiful young girl of about ten, Murasaki, who reminds him of her and who turns out to be her niece. He forces the girl to live in his mansion, and when she reaches the age of fourteen he marries her. This girl becomes Murasaki no Ue, the woman who is to remain at his side for the remainder of her life.

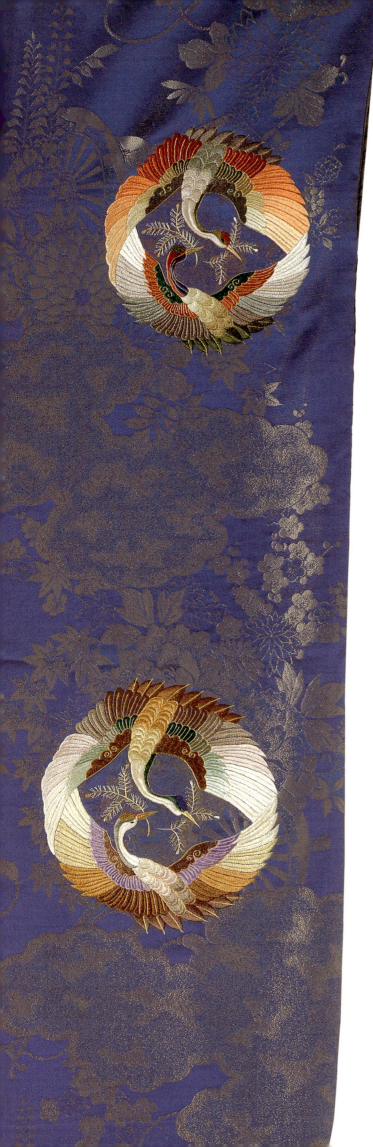

Tsuru maru
Circles of Cranes

Created to be worn in a coming-of-age ceremony, this kimono has been embroidered with a celebratory design of cranes within circles. As the same design is repeated across the garment, care has been taken with the balance of color in the motifs. The mauve fabric is decorated with a gorgeous woven design of flowers of the four seasons and clouds in gold thread, so motifs of birds or butterflies are more suitable than flowers for the embroidery.

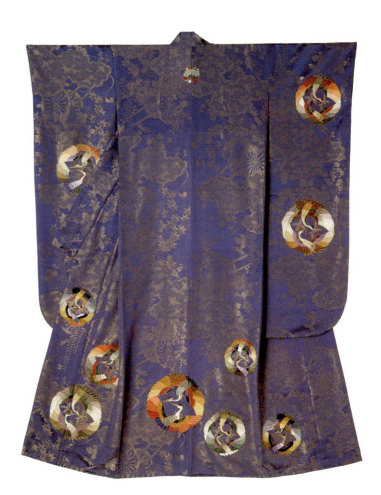

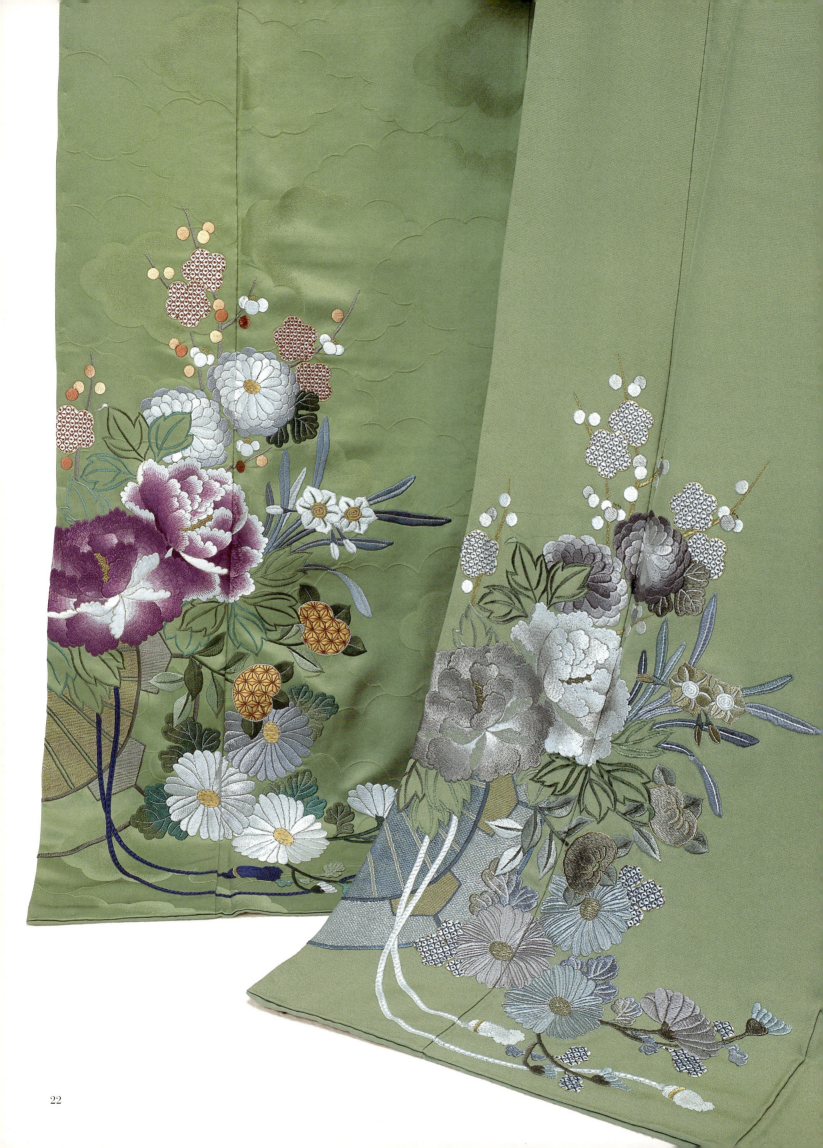

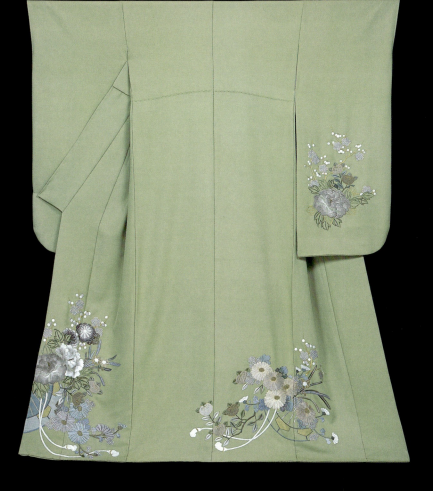

Agemaki and *Sawarabi*
Agemaki and Fern-Shoots

The titles of these two works are those of chapters forty-seven and forty-eight of *The Tale of Genji*, which are about the beautiful sisters Ōigimi and Naka no Kimi. *Agemaki* is a style of trefoil knot and is a name associated with the elder sister Ōigimi. In this chapter, her younger sister marries Genji's grandson Prince Niou, but Ōigimi remains spiritually pure and, unable to marry the person she loves, is overcome with sorrow and dies. Although Ōigimi lived an unostentatious life, in *Agemaki* I used gold and silver threads to express her elegance, while adding gradations in the flowers to hint at the depth of her character. In *Sawarabi* I expressed the lovable character of her younger sister through a large variety of colors, using a lot of purple to indicate her nobility.

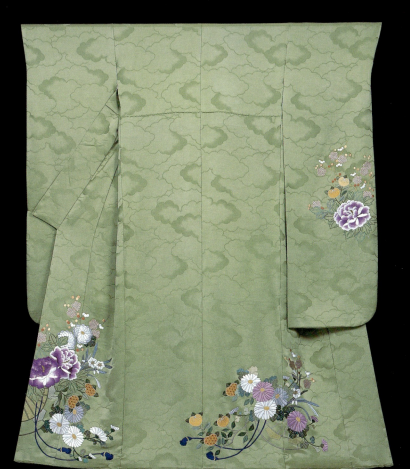

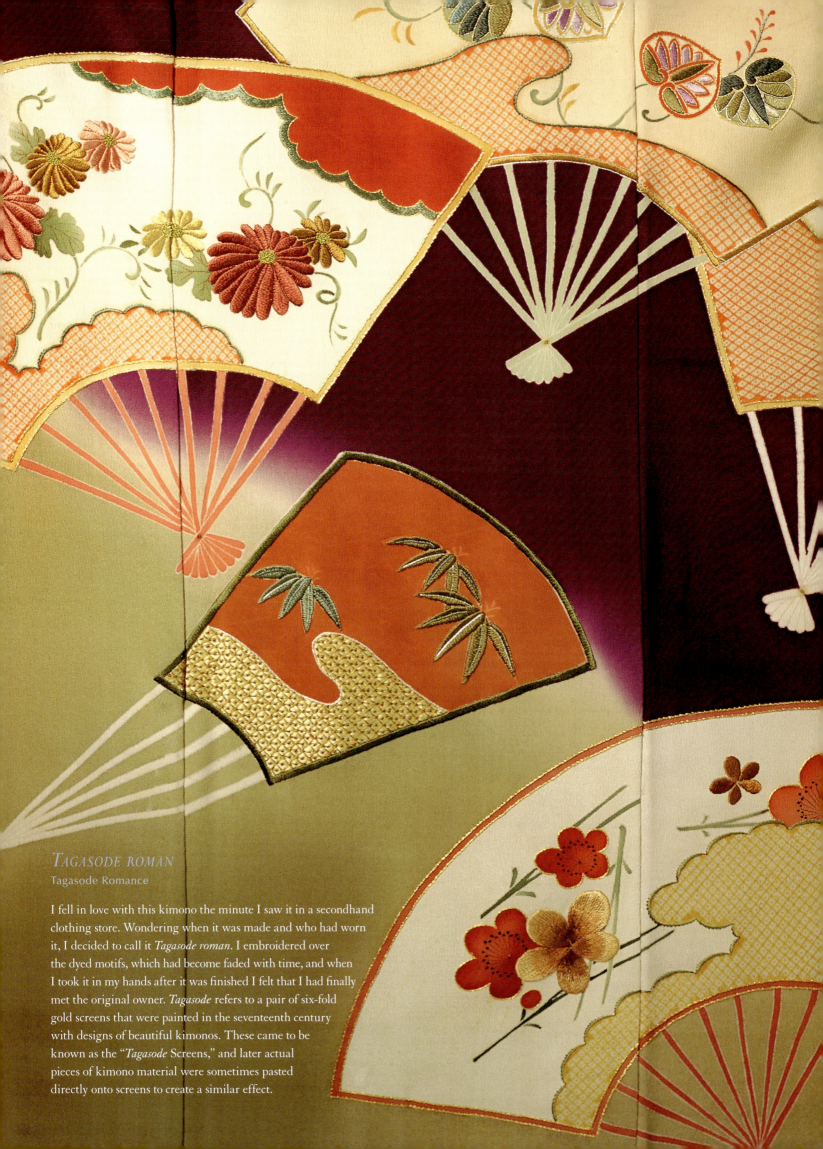

TAGASODE ROMAN
Tagasode Romance

I fell in love with this kimono the minute I saw it in a secondhand clothing store. Wondering when it was made and who had worn it, I decided to call it *Tagasode roman*. I embroidered over the dyed motifs, which had become faded with time, and when I took it in my hands after it was finished I felt that I had finally met the original owner. *Tagasode* refers to a pair of six-fold gold screens that were painted in the seventeenth century with designs of beautiful kimonos. These came to be known as the "*Tagasode* Screens," and later actual pieces of kimono material were sometimes pasted directly onto screens to create a similar effect.

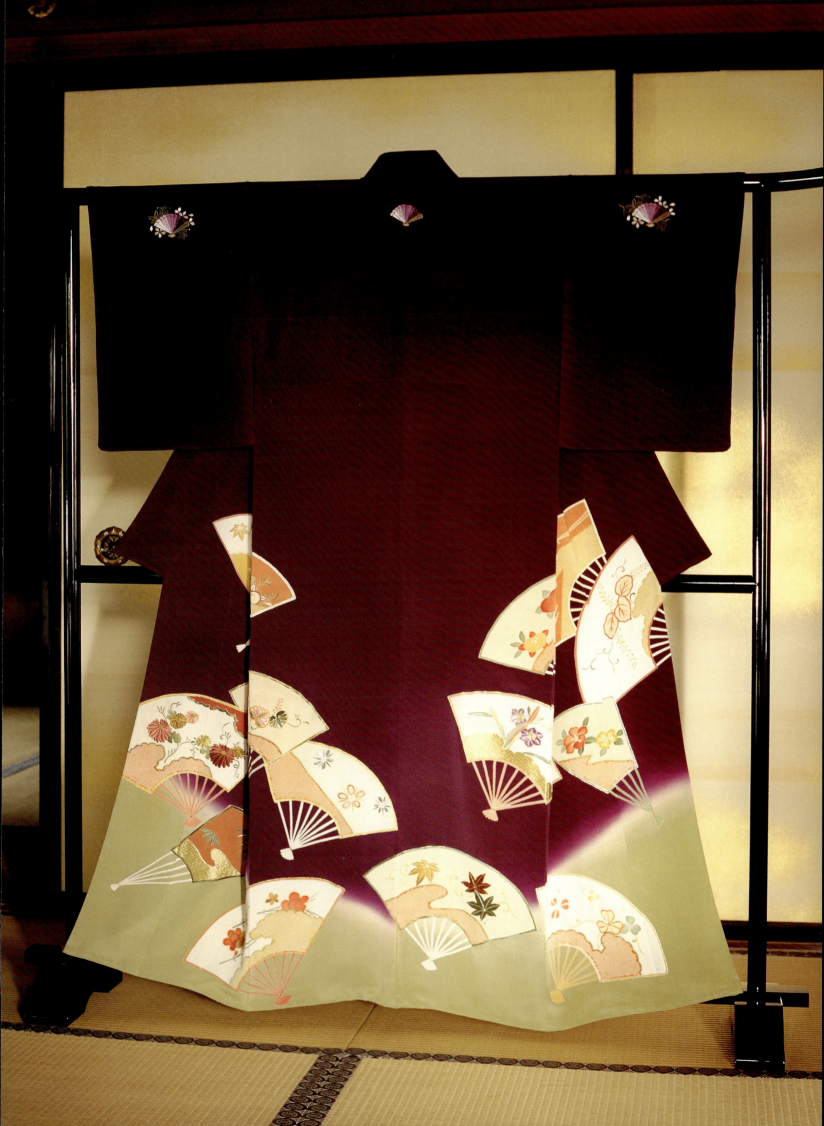

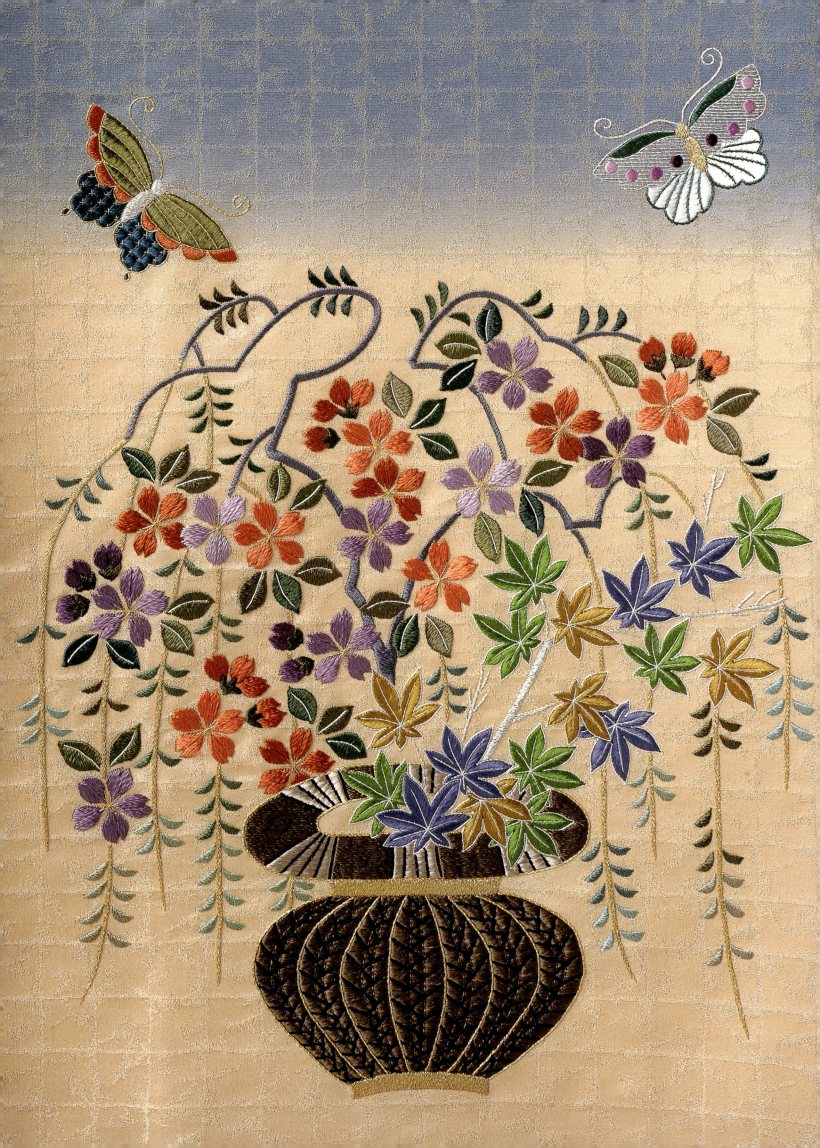

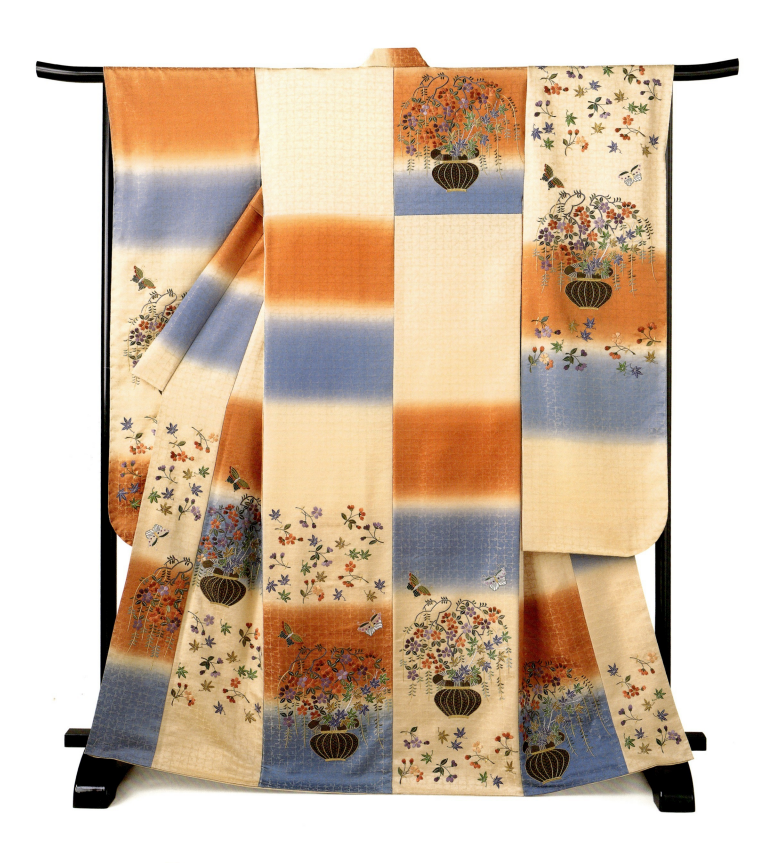

Hanagatami
Bamboo Flower Basket

When Emperor Keitai (485–527) was still crown prince, he set out on a long journey to the province of Yamato. Before departing, he left his favorite bamboo flower basket and a letter for the crown princess. The couple were not to meet again for many years, each going their own way until one day they were able to reunite, by chance, thanks to the bamboo basket.

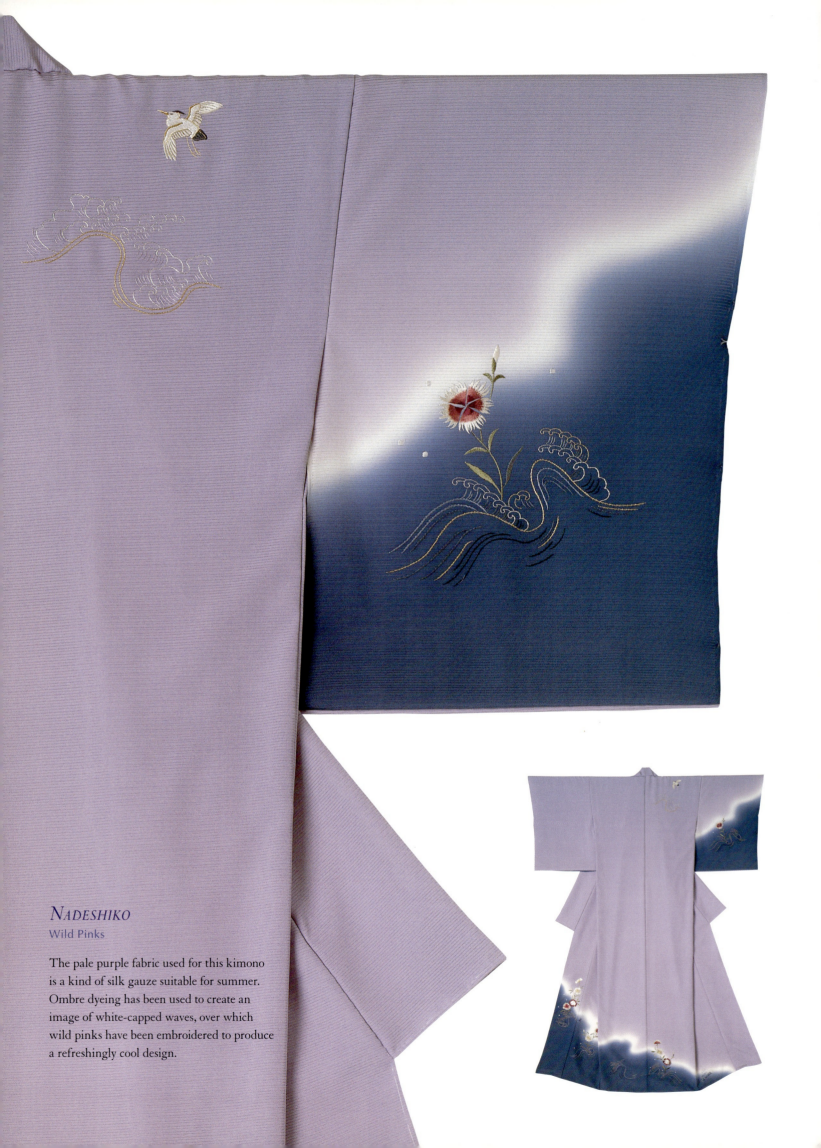

NADESHIKO
Wild Pinks

The pale purple fabric used for this kimono is a kind of silk gauze suitable for summer. Ombre dyeing has been used to create an image of white-capped waves, over which wild pinks have been embroidered to produce a refreshingly cool design.

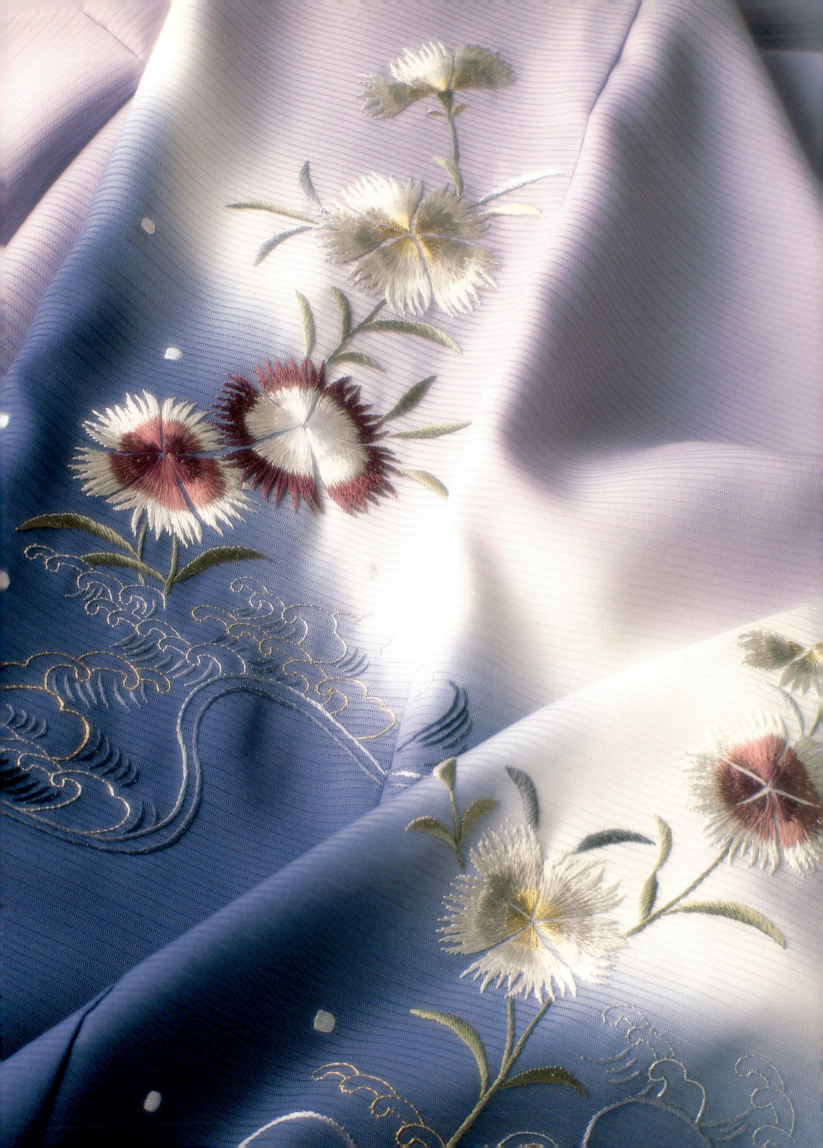

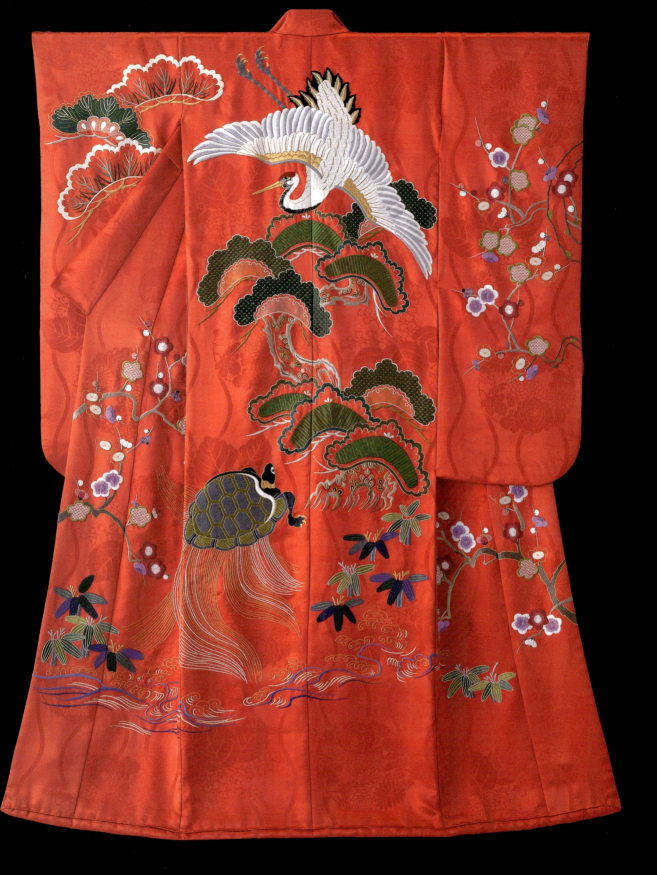

Kotohogi ni tsudoite
With Everyone's Blessings

This is a bridal gown with a design of a crane, turtle, and pine trees on red. An old, pure white bridal gown had become soiled, so it was dyed vermilion red and embroidered with the auspicious symbols of the crane and turtle. There is an old Japanese saying that "Cranes live one thousand years, turtles ten thousand," and so patterns comprising these two creatures are often used to symbolize longevity. The practice of depicting cranes with pine trees is one that dates back to the Heian period.

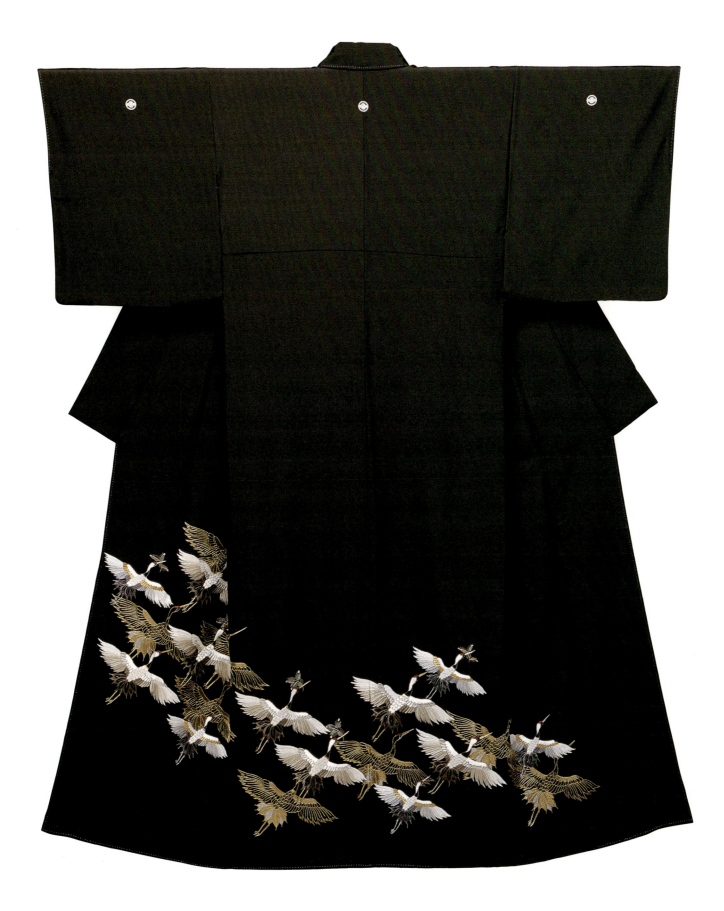

GUNKAKU
Flock of Cranes

This formal kimono was designed to be worn at weddings, and so it has been embroidered with an auspicious design of cranes. A wedding marks the day when a couple set out on a new life together, and this is represented by a sumptuous design of a flock of cranes all taking off together. In order to create a feeling of class and elegance, I avoided using color, restricting my threads to gold, silver, white, and gray.

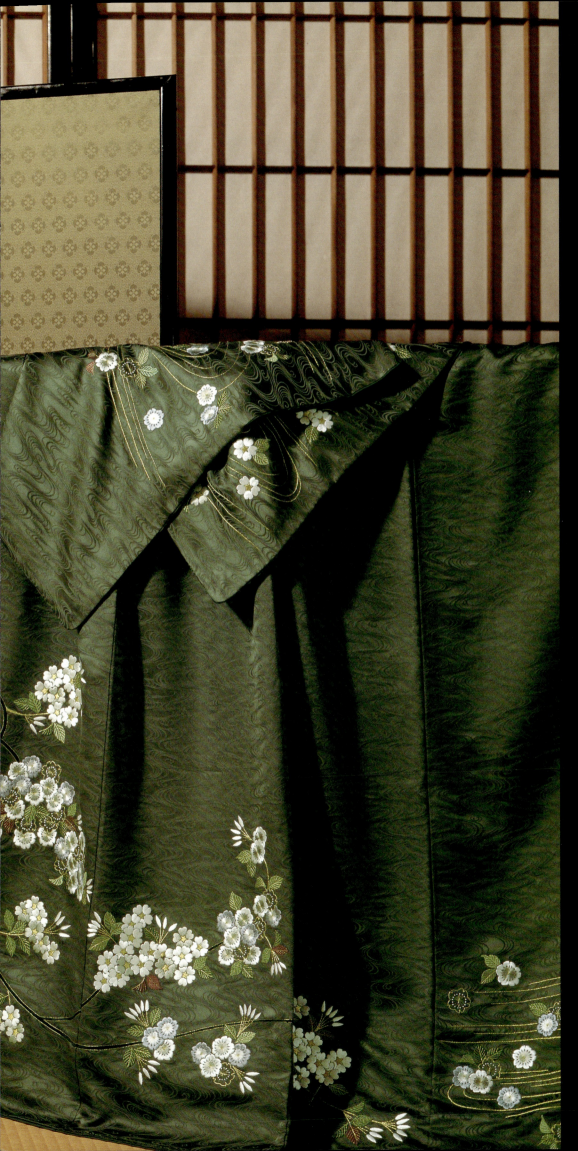

AMAGIGOE
Crossing Mt. Amagi

I am sometimes so deeply moved by a melody or poem that it motivates me to create a new work. *Amagigoe* is a popular song about the passions that exist in a woman's heart, and I believe that when the singer is wearing a kimono based on the image of this song, it becomes real poetry.

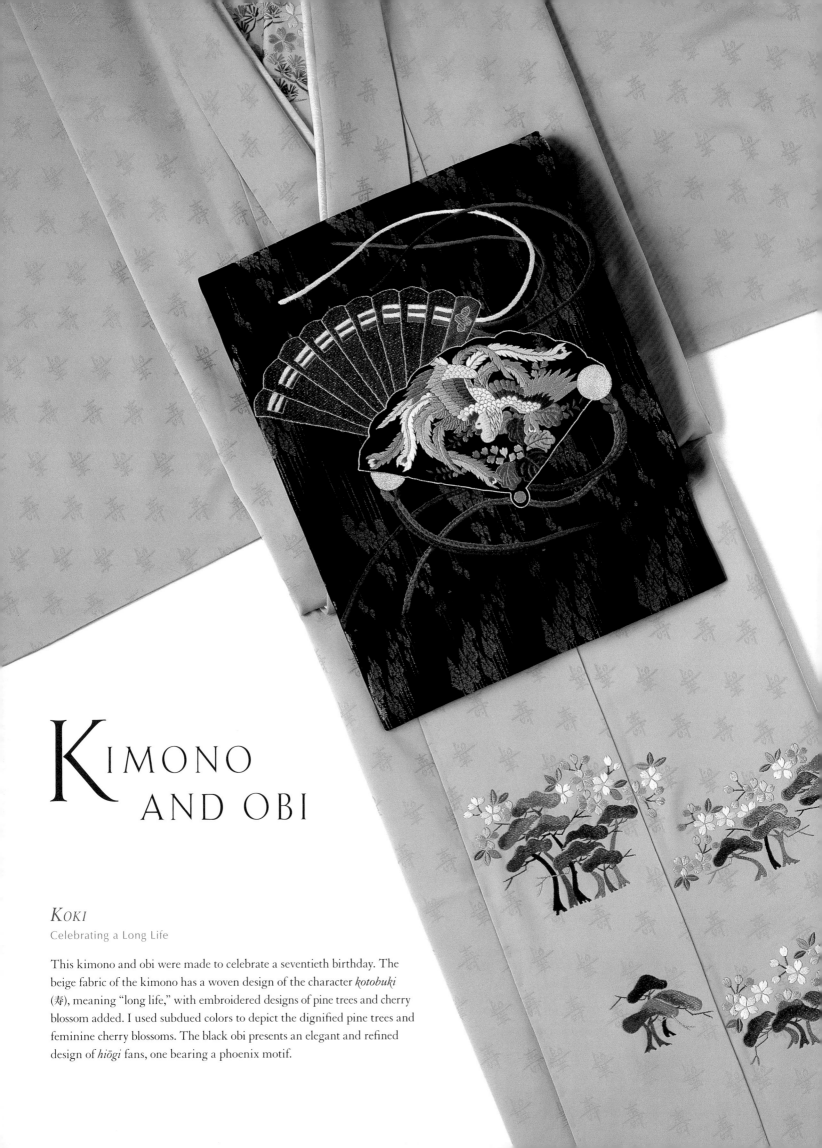

KIMONO AND OBI

KOKI
Celebrating a Long Life

This kimono and obi were made to celebrate a seventieth birthday. The beige fabric of the kimono has a woven design of the character *kotobuki* (寿), meaning "long life," with embroidered designs of pine trees and cherry blossom added. I used subdued colors to depict the dignified pine trees and feminine cherry blossoms. The black obi presents an elegant and refined design of *hiōgi* fans, one bearing a phoenix motif.

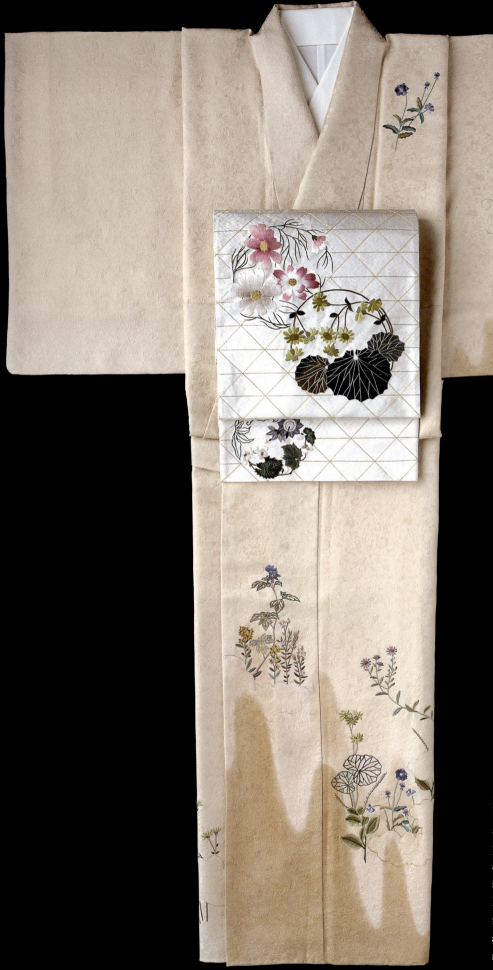

Autumnal Flowers

This kimono has a design of autumnal flowers on gradated, light brown fabric, while the obi bears autumnal flowers on a silver *tsuzure-ori* (figured brocade) fabric. The embroidered autumnal wild flowers are dignified, yet pretty. I wanted them to appear as if they were so delicate they would sway in the lightest autumn breeze. In decorating the obi, I considered its balance with the kimono and arranged the flowers into a circular motif.

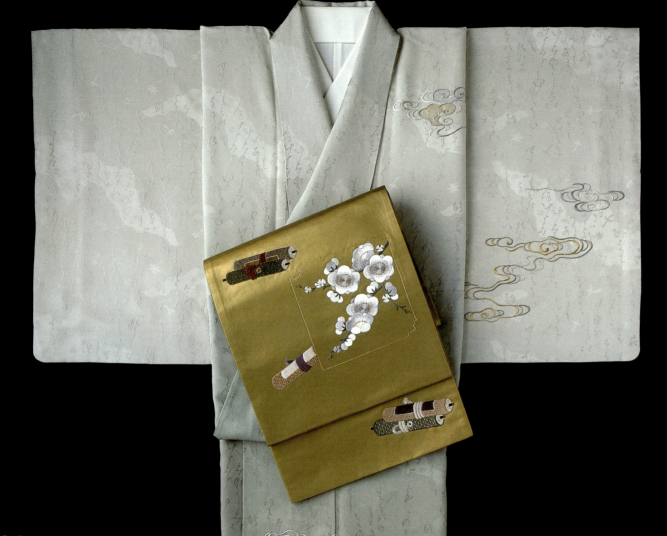

U<small>MEGAE</small>
The Spray of Plum-Blossoms

The kimono has a woven pattern of Japanese characters with a design of clouds on grey fabric, and the obi a design of plum blossoms and scrolls on woven gold fabric. Combining a grey kimono with a gold obi, I limited the embroidery to subdued colors in order to achieve a refined result. The text of poems by the so-called Thirty-six Immortal Poets of the Heian period has been woven into the fabric of the kimono, and the embroidery of the clouds was restrained in order not to encroach upon these. The concept for the design of the obi comes from *The Tale of Genji*, the motif of plum blossoms and letter scrolls expressing the exchange of letters between lovers in the spring when the plum trees are in bloom.

SPIDER CHRYSANTHEMUMS

Chrysanthemums have been prized by the Japanese since ancient times for their dignity and long-lasting blooms. Originally introduced into Japan from China, they have been used in motifs for clothes or the backs of mirrors since the Heian period. An elegant flower, it often appears in the designs for kimono and obi, now worn mostly for weddings, funerals, and other formal occasions.

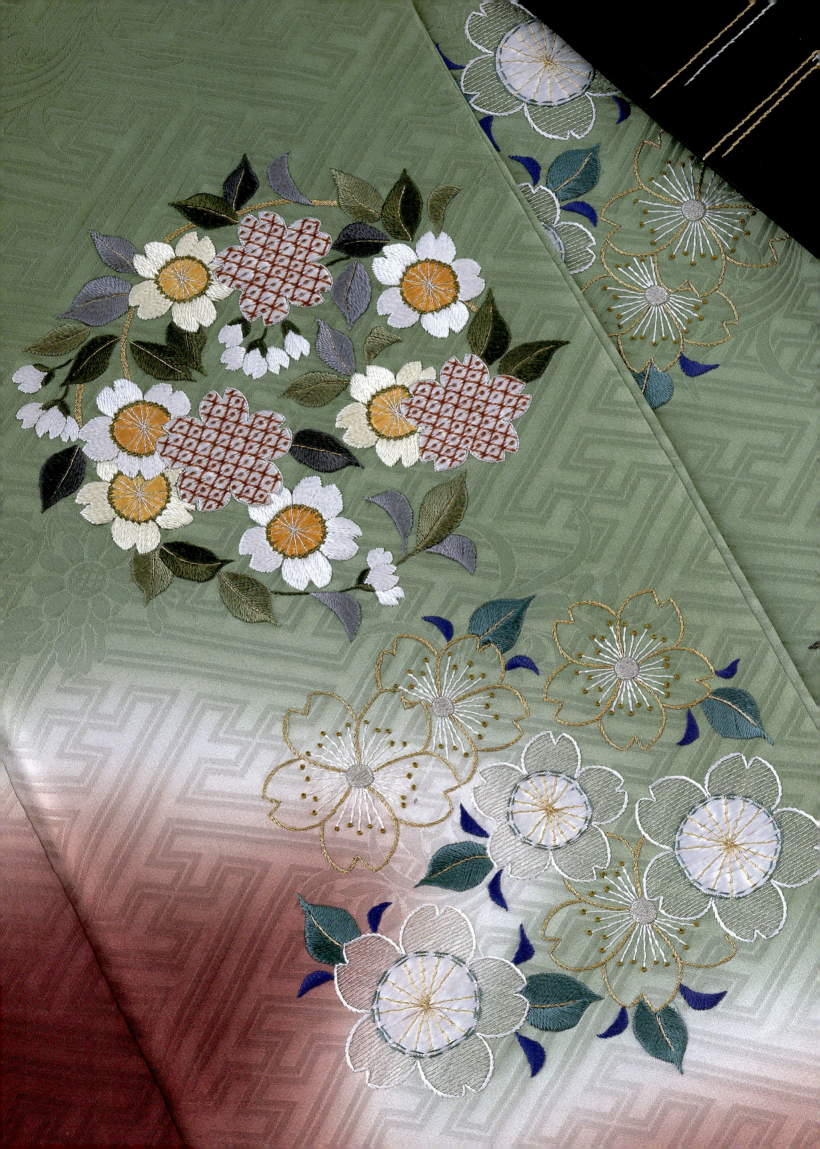

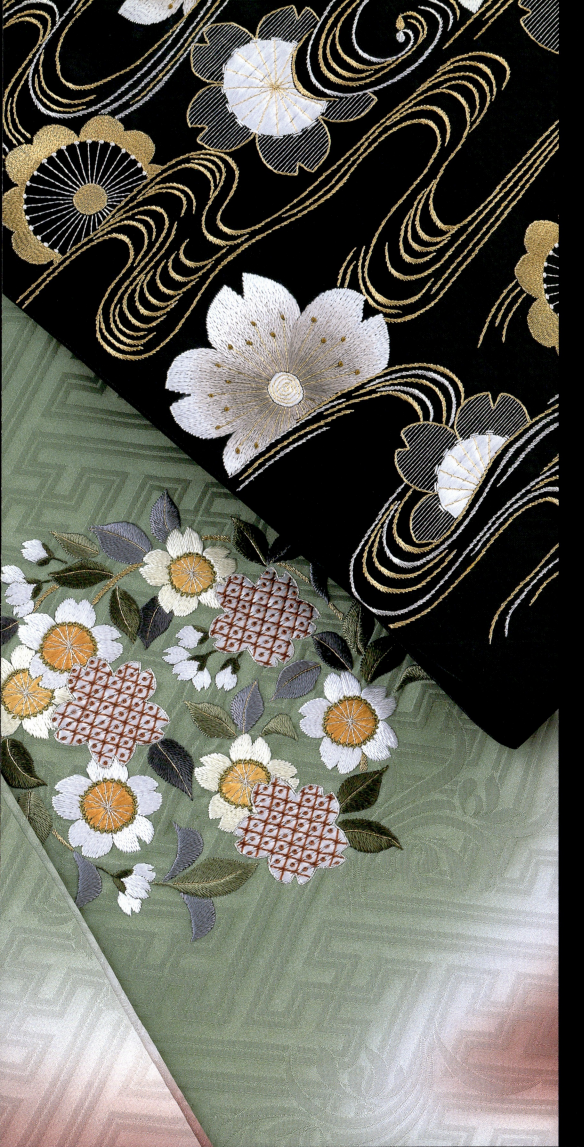

Cherry Blossoms

Cherry blossom have been the most beloved of all flowers by the Japanese people since the Heian period. The overwhelming beauty of the blossom makes it ideally suited for bridal costumes. The fabric of this long-sleeved kimono has a *sayagata* pattern of interlocking Buddhist swastika symbols woven into it, imbuing the garment with a feeling of elegance, while the gradation of the ombre dyeing from green to dark red creates a festive mood. The obi presents a checkered design in different shades of black with a motif of cherry blossoms and flowing water expressed through gold and silver thread. The cherry blossom designs harmonize the kimono with the obi.

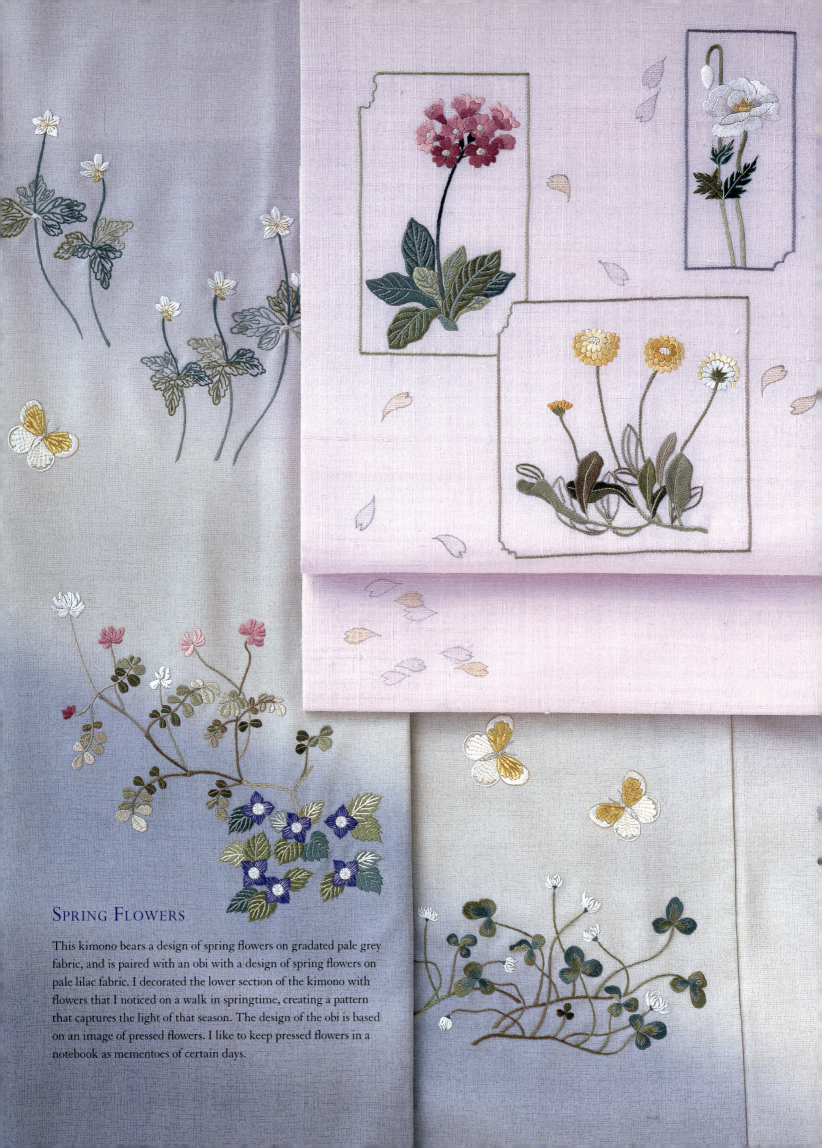

Spring Flowers

This kimono bears a design of spring flowers on gradated pale grey fabric, and is paired with an obi with a design of spring flowers on pale lilac fabric. I decorated the lower section of the kimono with flowers that I noticed on a walk in springtime, creating a pattern that captures the light of that season. The design of the obi is based on an image of pressed flowers. I like to keep pressed flowers in a notebook as mementoes of certain days.

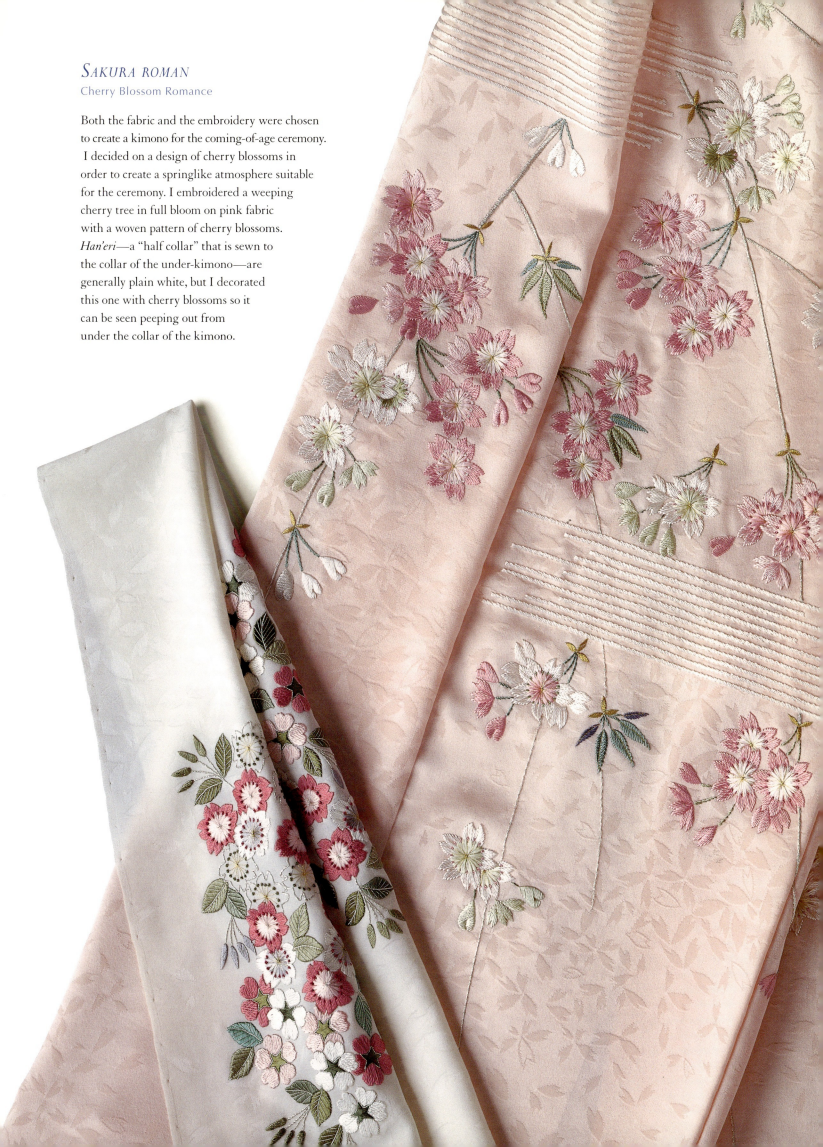

SAKURA ROMAN
Cherry Blossom Romance

Both the fabric and the embroidery were chosen to create a kimono for the coming-of-age ceremony. I decided on a design of cherry blossoms in order to create a springlike atmosphere suitable for the ceremony. I embroidered a weeping cherry tree in full bloom on pink fabric with a woven pattern of cherry blossoms. *Han'eri*—a "half collar" that is sewn to the collar of the under-kimono—are generally plain white, but I decorated this one with cherry blossoms so it can be seen peeping out from under the collar of the kimono.

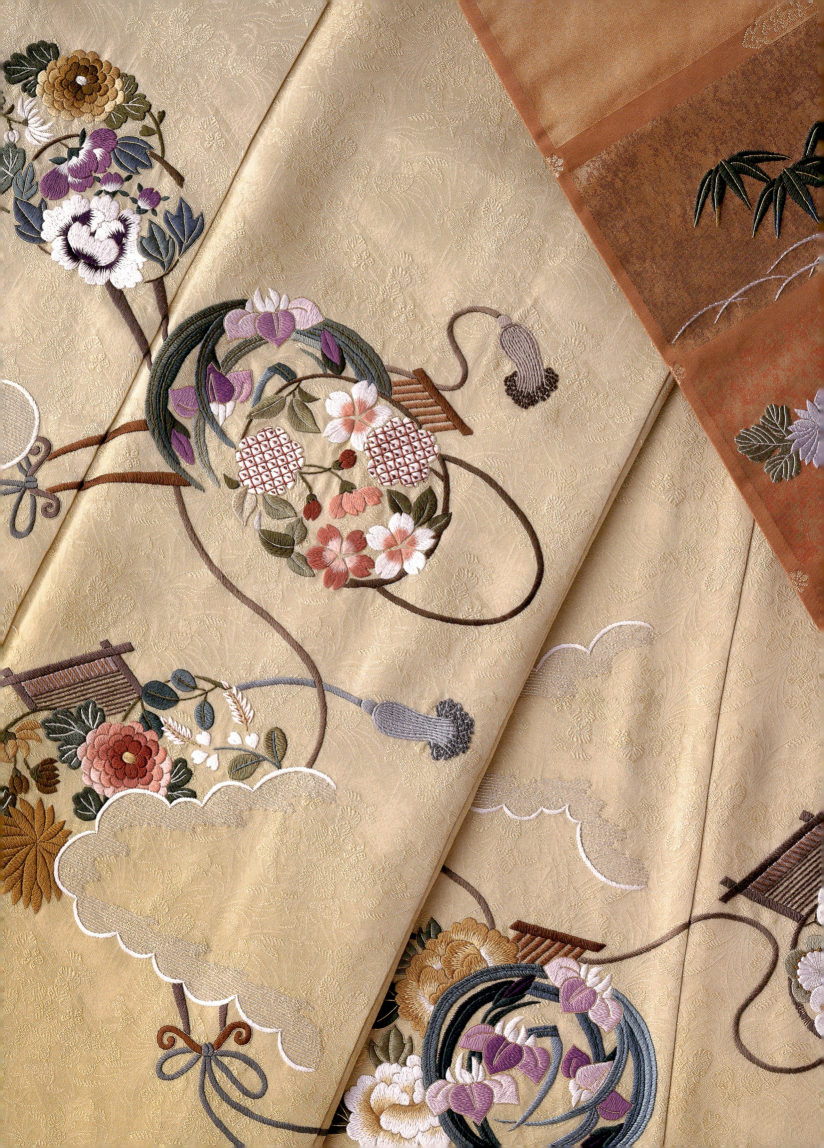

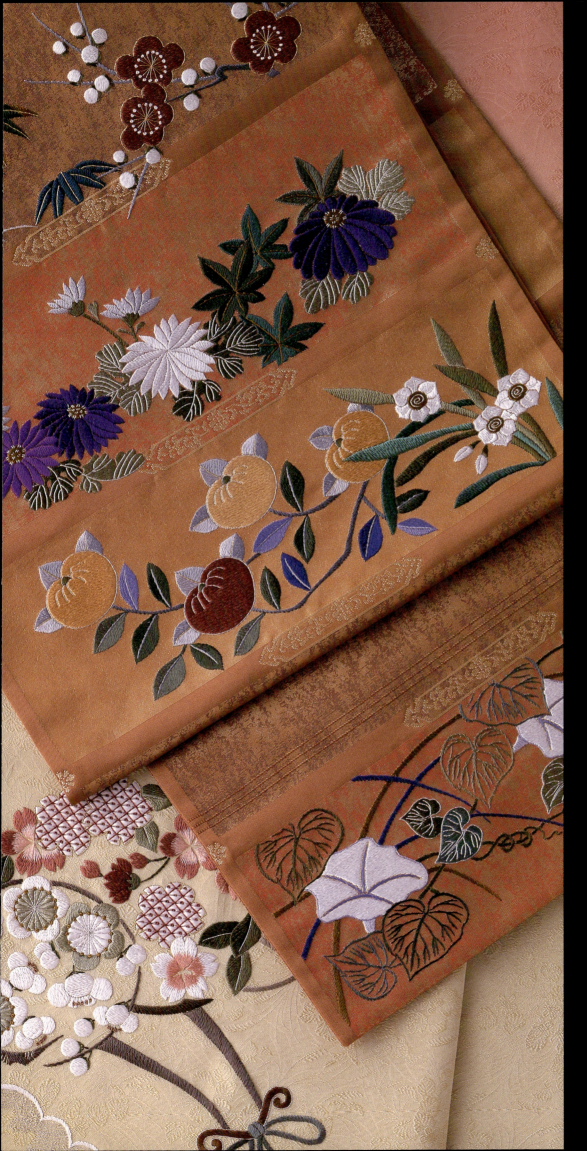

Tamakazura

This design is based on the image of the character Tamakazura, who appears in chapter twenty-two of *The Tale of Genji*. Of all the women characters in this book, whose lives are at the mercy of fate, Tamakazura is the happiest. The kimono is dyed in a warm red and yellow gradation and decorated with harmonious circular floral motifs. The color of the obi complements the red of the kimono and it has been decorated with horizontal bands of flowers depicting the four seasons.

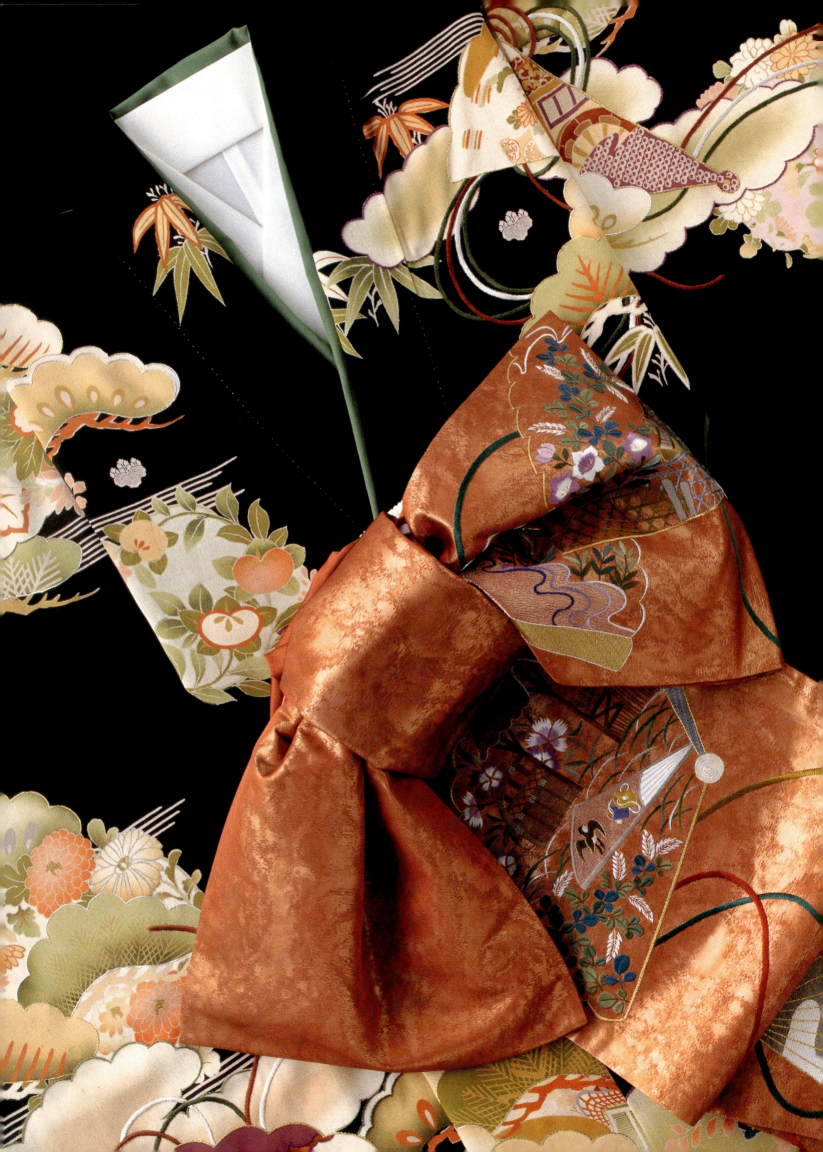

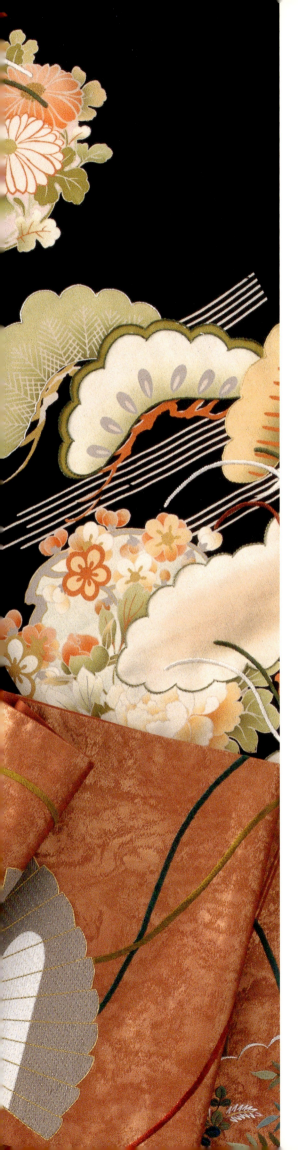

Azumaya
The Eastern House

Black kimono with long sleeves were often used as bridal costumes during the Meiji to early Shōwa periods. In this work I have taken an old kimono with a dyed pattern of pine and shell buckets and added new embroidery. The obi has been embroidered with a design alluding to chapter fifty of *The Tale of Genji*, entitled *Azumaya*. The motif on the fan is the scenery of Uji in Kyoto, where the chapter was set, while the three cords represent the heroine, Ukifune, and the two men vying for her attentions. The combination with the pine trees and cords on the kimono and the balance between the black of the kimono and the vermilion red of the obi create an elegant tone.

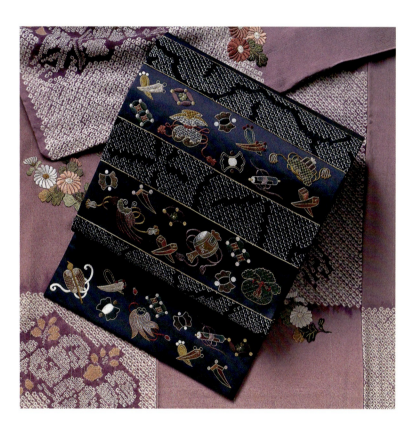

Takara zukushi
Assorted Treasures

This kimono has a design of chrysanthemums on mauve *shibori zome* fabric and is paired with an obi with a design of assorted treasures on indigo fabric. *Shibori* fabric has been appliquéd in horizontal bands on the obi, adding zest to the design. The motif of assorted treasures originated in ancient China, and was later adapted to suit Japanese aesthetics. Common motifs include a straw raincoat or hat to protect the wearer from disaster, a magic hammer that produces treasure when it is struck, and a purse to carry treasure, but the items included vary according to the period the design was made. It is considered a lucky design and is often used for kimono.

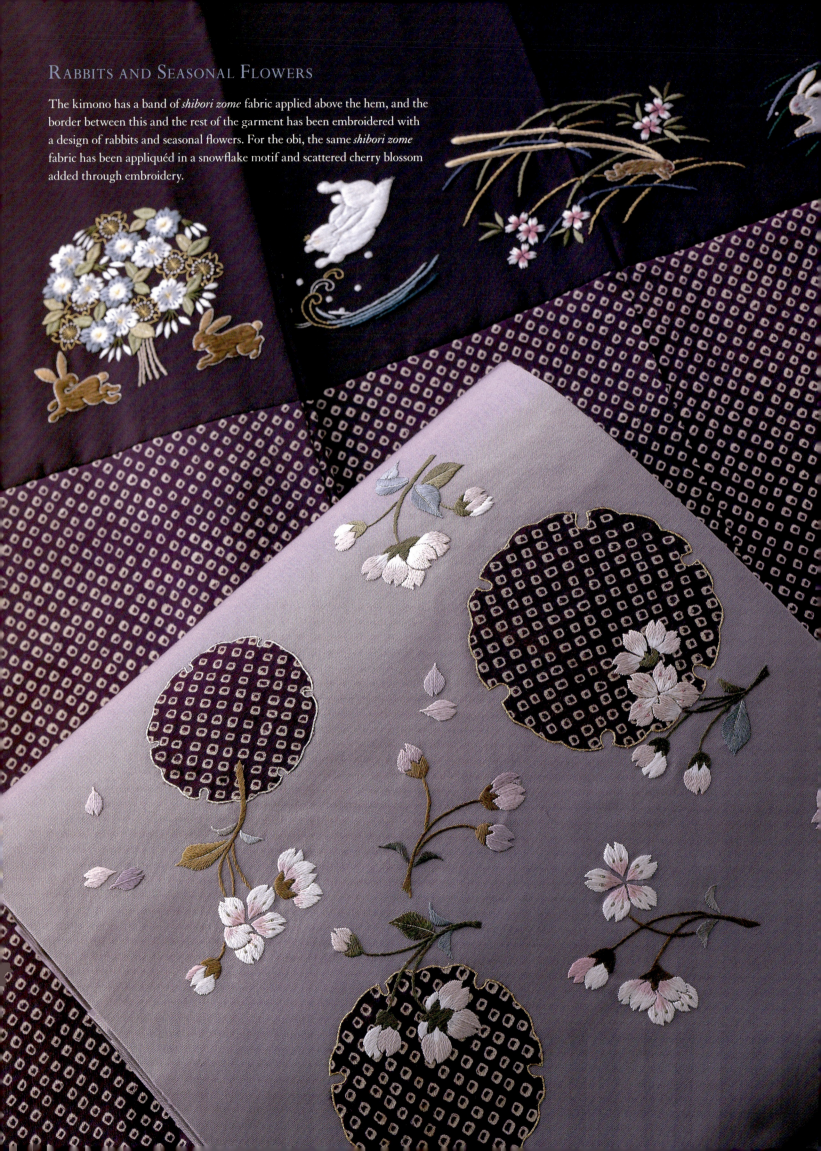

Rabbits and Seasonal Flowers

The kimono has a band of *shibori zome* fabric applied above the hem, and the border between this and the rest of the garment has been embroidered with a design of rabbits and seasonal flowers. For the obi, the same *shibori zome* fabric has been appliquéd in a snowflake motif and scattered cherry blossom added through embroidery.

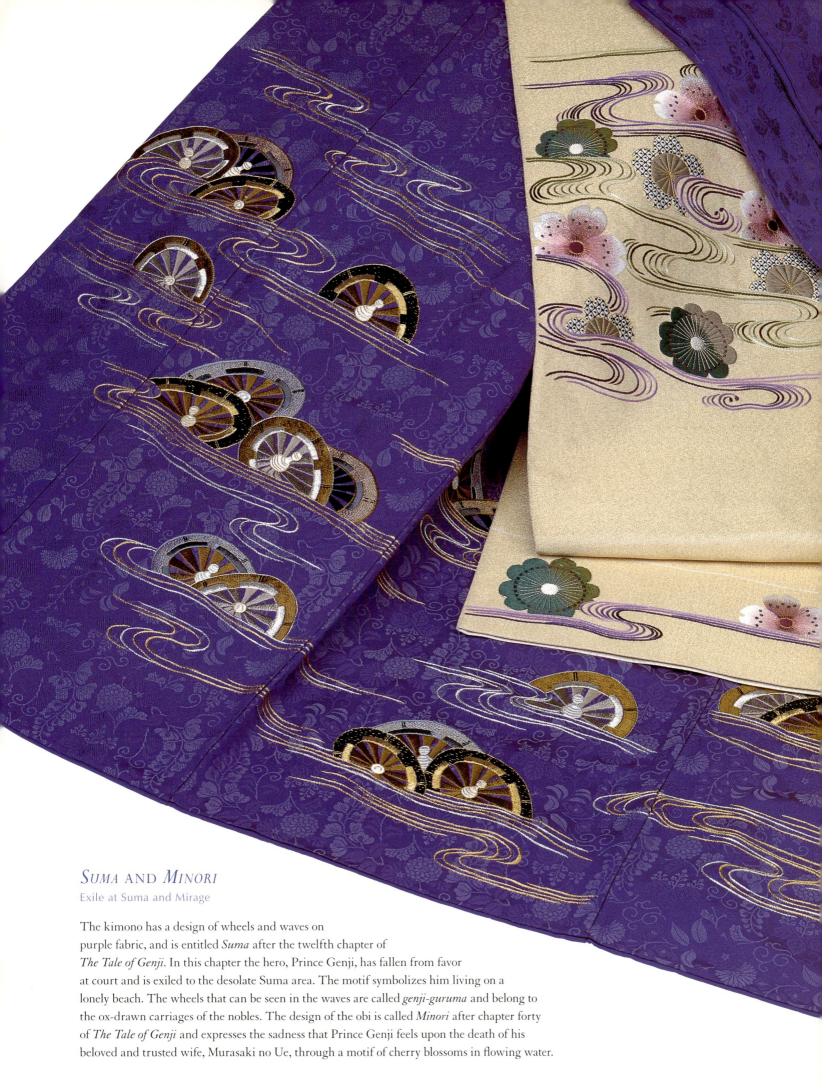

SUMA AND MINORI
Exile at Suma and Mirage

The kimono has a design of wheels and waves on purple fabric, and is entitled *Suma* after the twelfth chapter of *The Tale of Genji*. In this chapter the hero, Prince Genji, has fallen from favor at court and is exiled to the desolate Suma area. The motif symbolizes him living on a lonely beach. The wheels that can be seen in the waves are called *genji-guruma* and belong to the ox-drawn carriages of the nobles. The design of the obi is called *Minori* after chapter forty of *The Tale of Genji* and expresses the sadness that Prince Genji feels upon the death of his beloved and trusted wife, Murasaki no Ue, through a motif of cherry blossoms in flowing water.

Kagerō and Asagao
The Gossamer-Fly and Asagao

This kimono has a design of mayflies and autumnal grasses on silk gauze, while the obi has a design of morning glory on lined gauze. The design of the kimono was based on the image inspired by chapter fifty-two of *The Tale of Genji* entitled *Kagerō*. The main subject of this chapter, Kaoru, reflects on the mercilessness of life, comparing man's time on this world to the fleeting lives of the mayflies. The design for the obi is based on chapter twenty entitled *Asagao*: although Asagao secretly desired Prince Genji, she repeatedly rebuffed his advances and I have expressed this by covering an embroidery of *asagao* (morning glory) flowers with silk gauze.

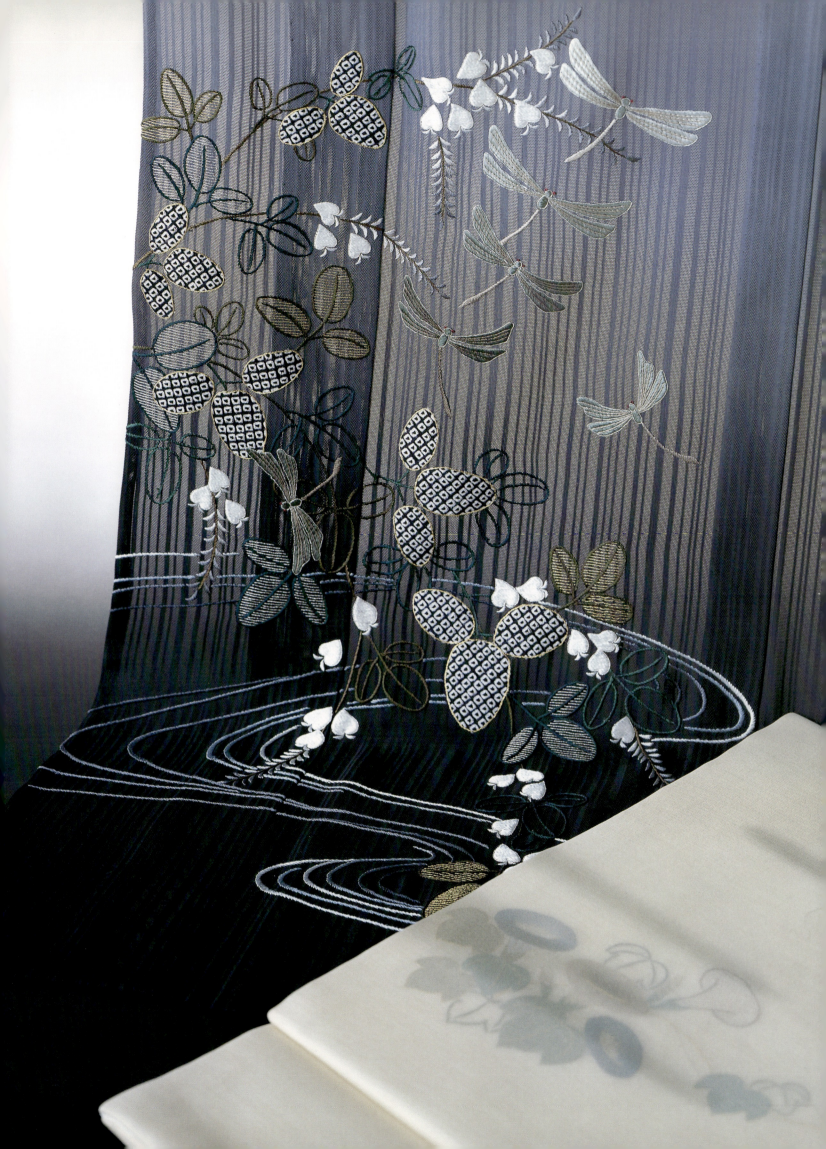

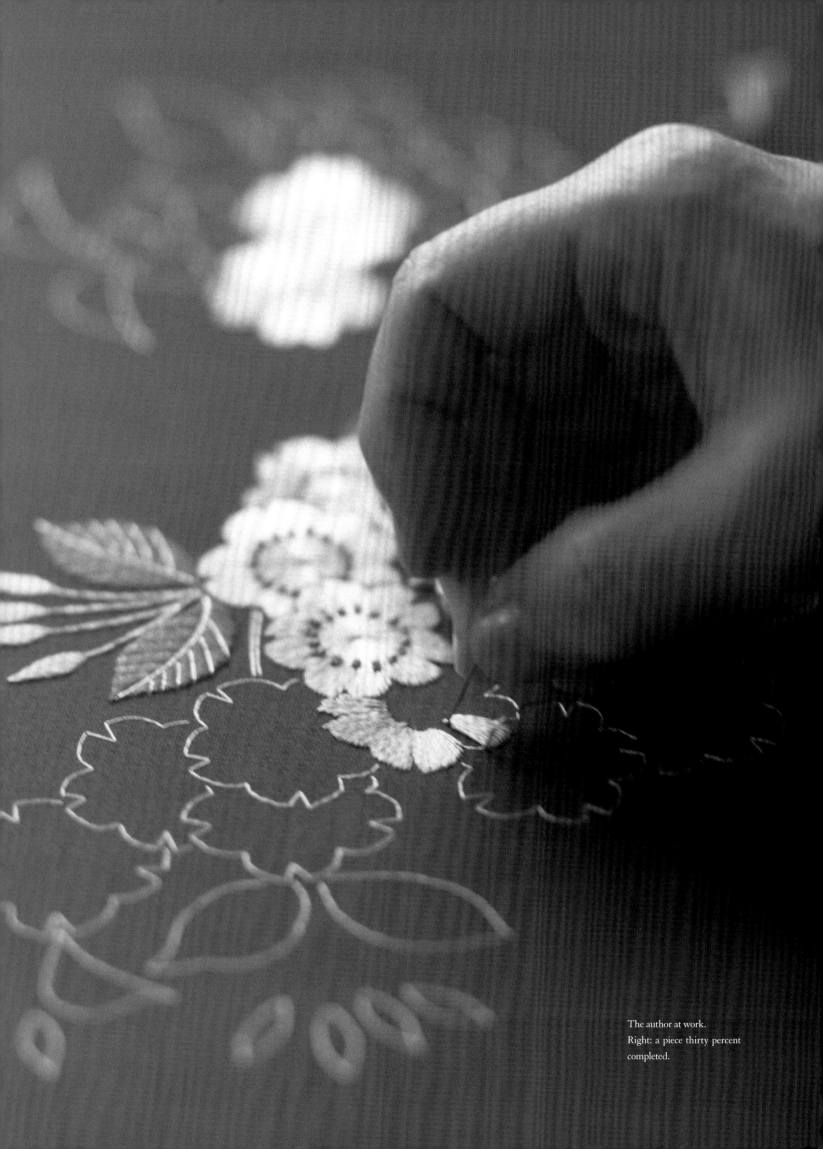

The author at work.
Right: a piece thirty percent completed.

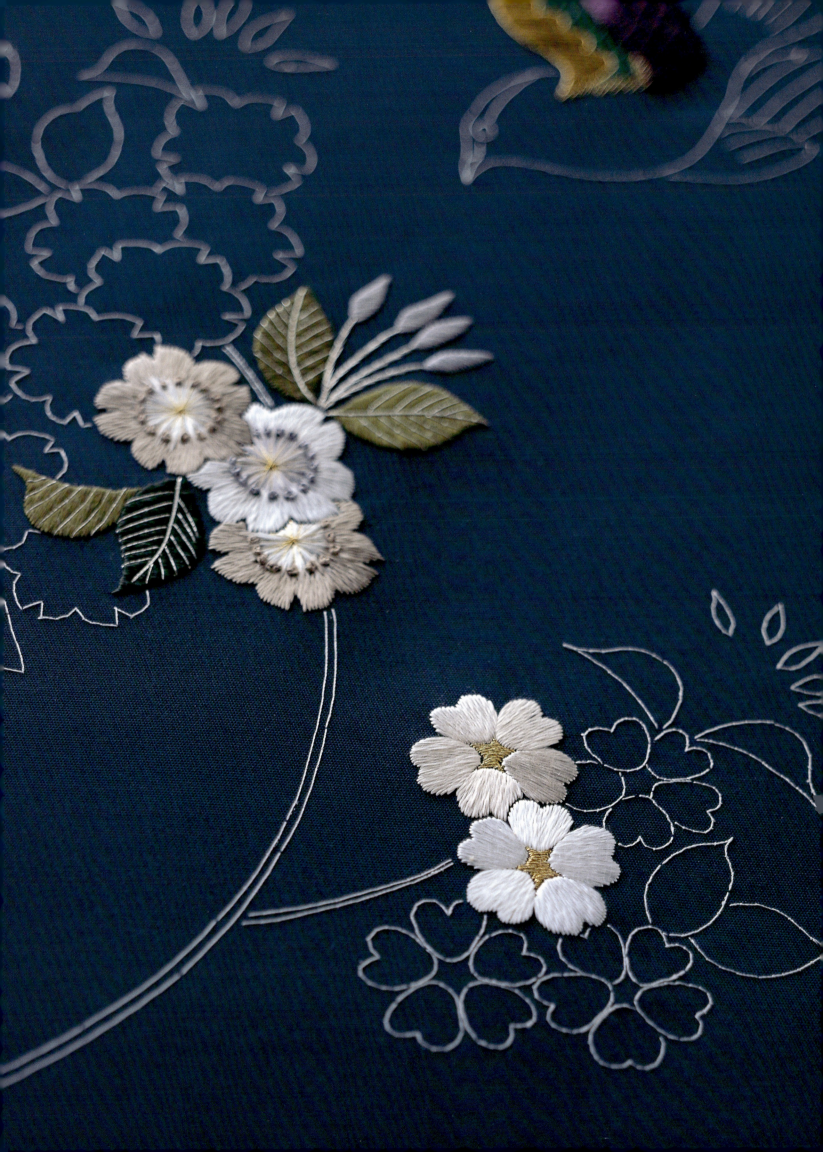

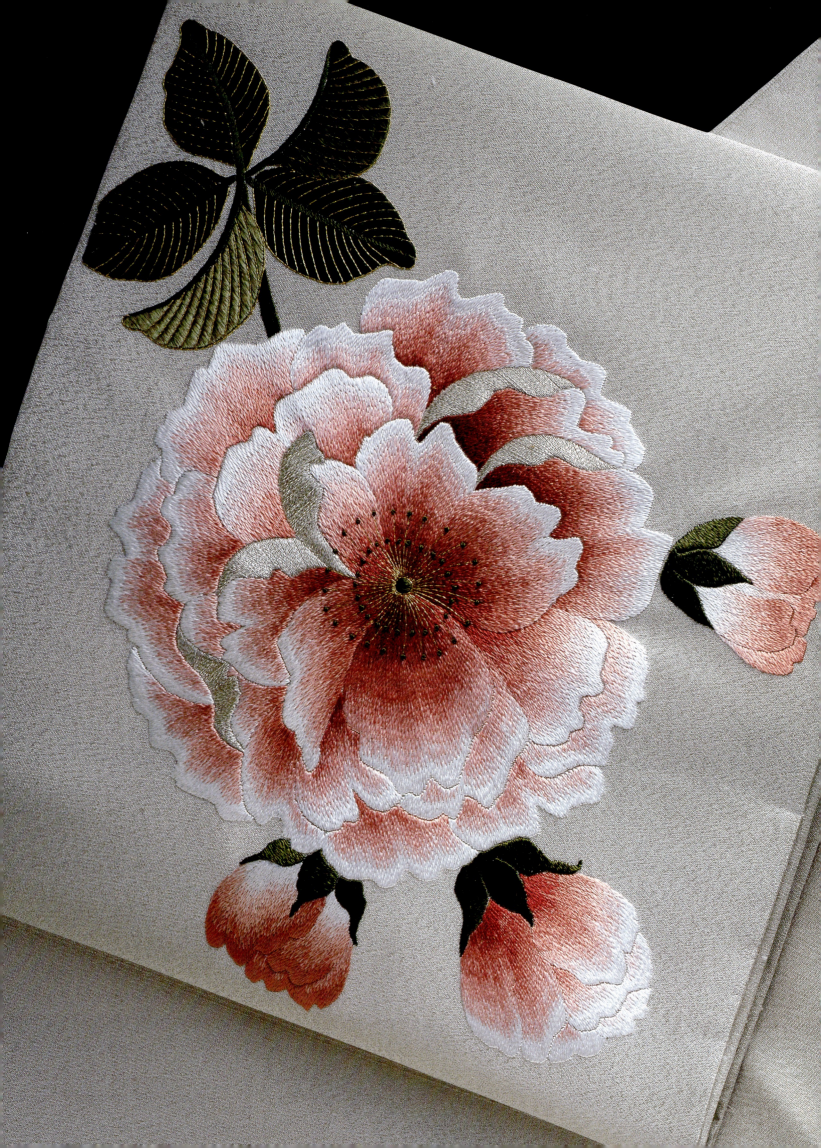

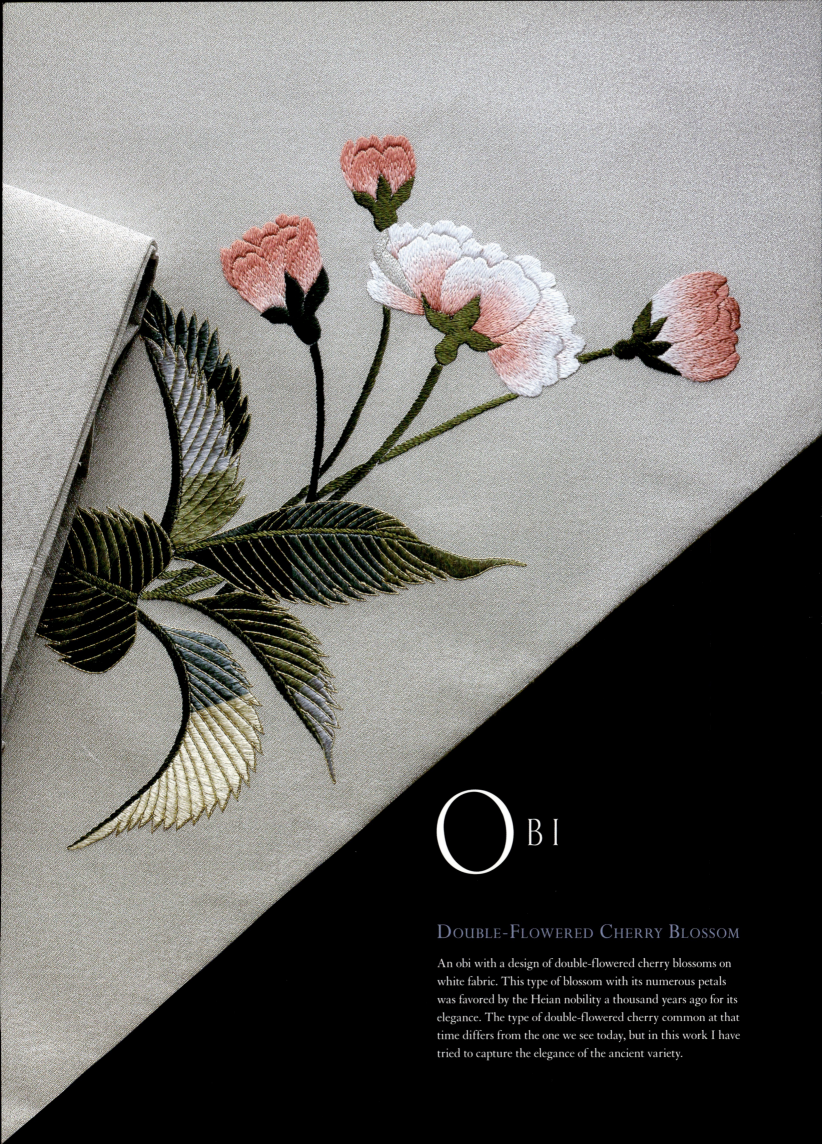

Obi

Double-Flowered Cherry Blossom

An obi with a design of double-flowered cherry blossoms on white fabric. This type of blossom with its numerous petals was favored by the Heian nobility a thousand years ago for its elegance. The type of double-flowered cherry common at that time differs from the one we see today, but in this work I have tried to capture the elegance of the ancient variety.

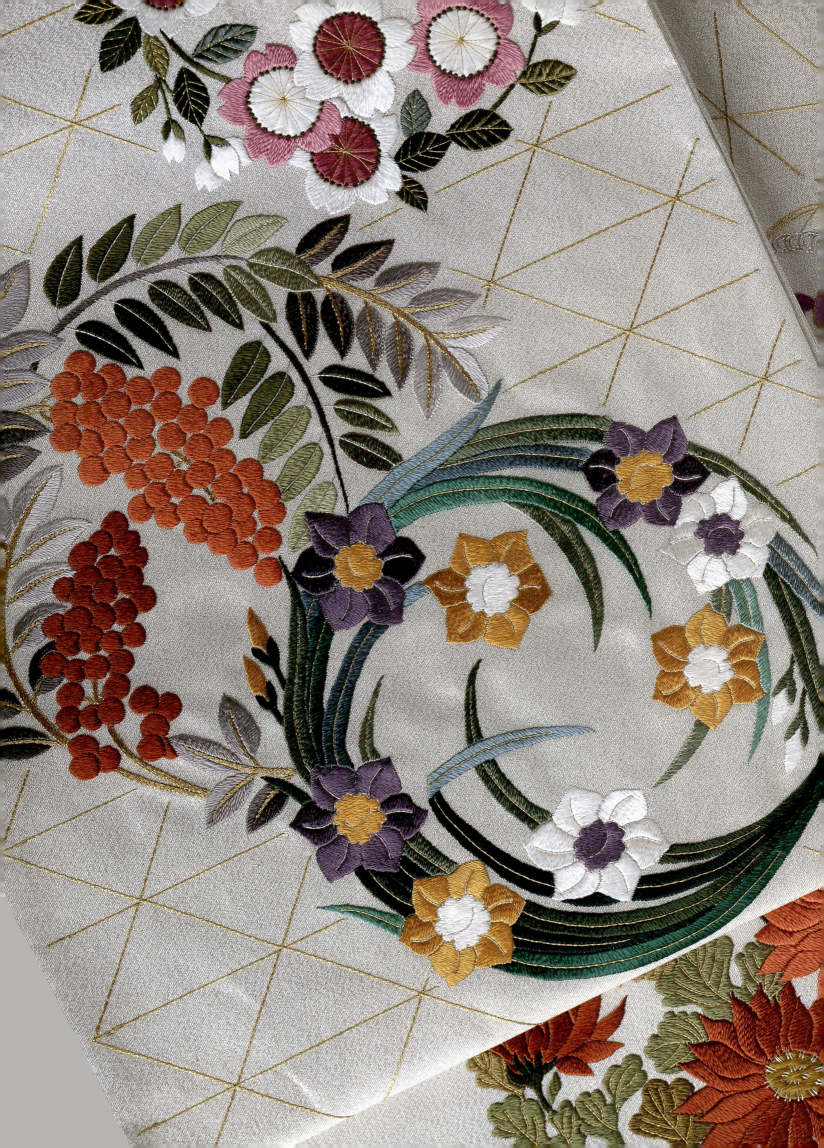

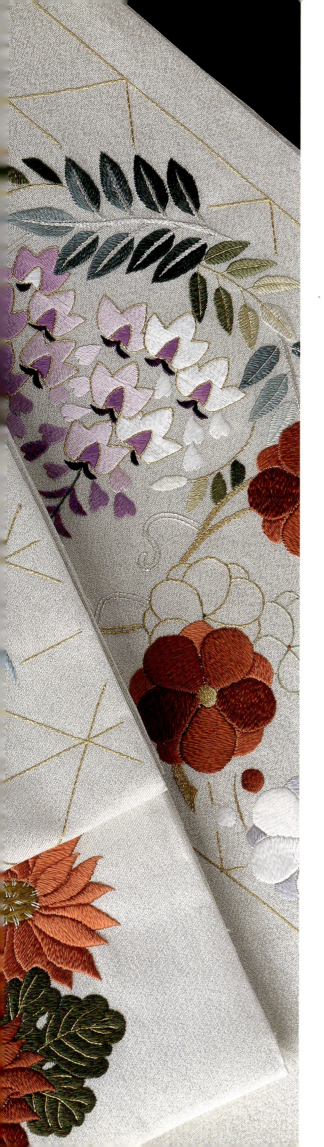

CIRCULAR FLORAL MOTIFS

This obi was embroidered for the coming-of-age ceremony with a design of flowers of the four seasons including daffodils, nandina, cherry blossoms, chrysanthemums, plum blossoms, and wisteria, represented singularly in circular motifs. The background has been embroidered with a scale design, which is said to protect the wearer.

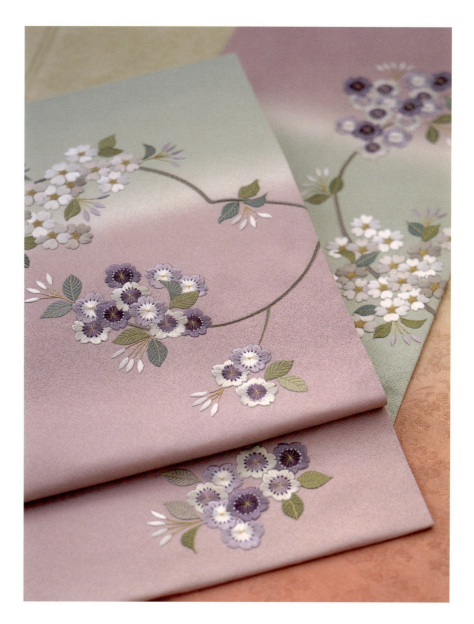

CHERRY BLOSSOMS

The pale green and pale purple gradations of the fabric represent the colors of spring. The way in which the cherry blossoms spread out over the blank space symbolizes its reveling in the return of spring and blooming in all its glory.

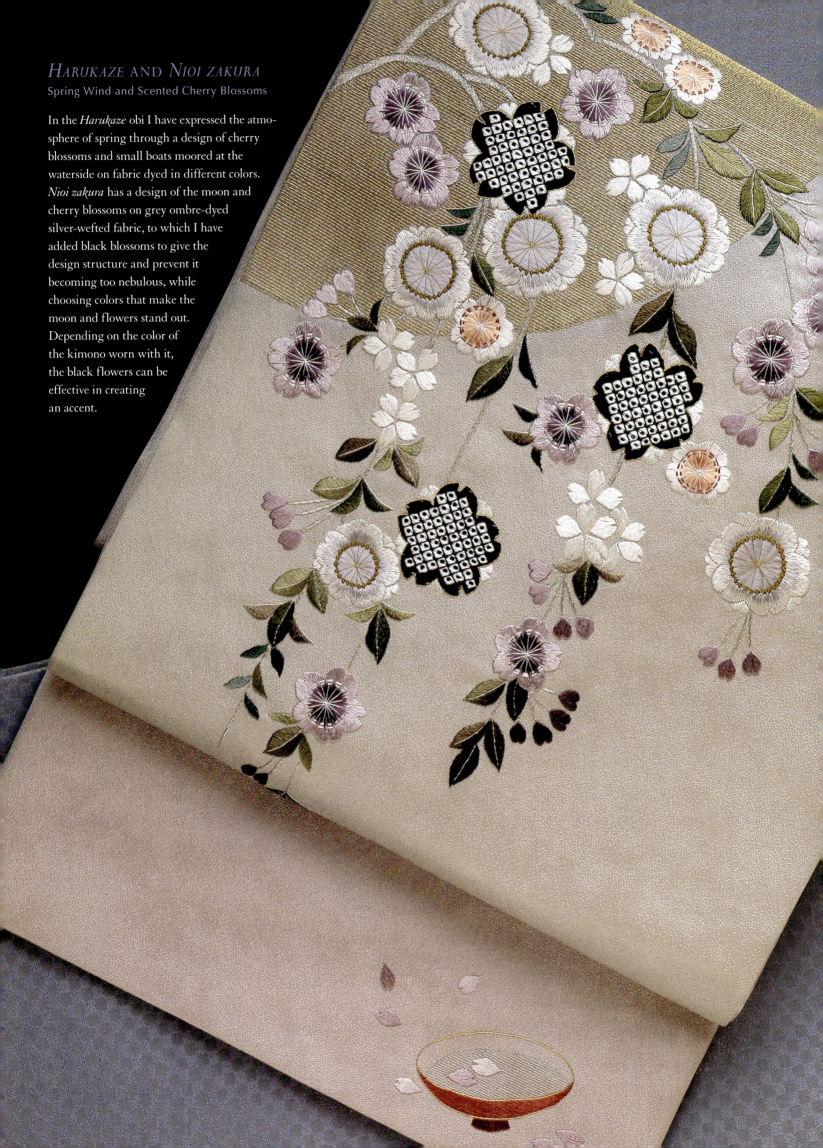

Harukaze and Nioi zakura
Spring Wind and Scented Cherry Blossoms

In the *Harukaze* obi I have expressed the atmosphere of spring through a design of cherry blossoms and small boats moored at the waterside on fabric dyed in different colors. *Nioi zakura* has a design of the moon and cherry blossoms on grey ombre-dyed silver-wefted fabric, to which I have added black blossoms to give the design structure and prevent it becoming too nebulous, while choosing colors that make the moon and flowers stand out. Depending on the color of the kimono worn with it, the black flowers can be effective in creating an accent.

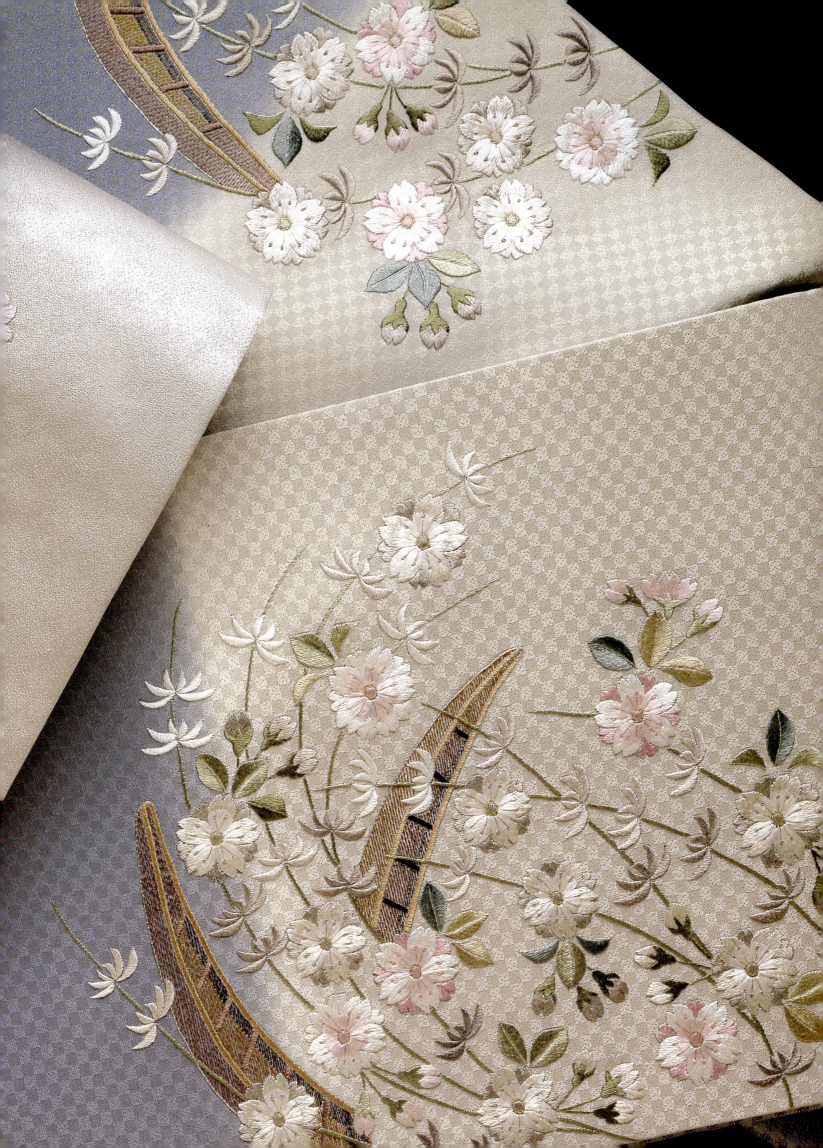

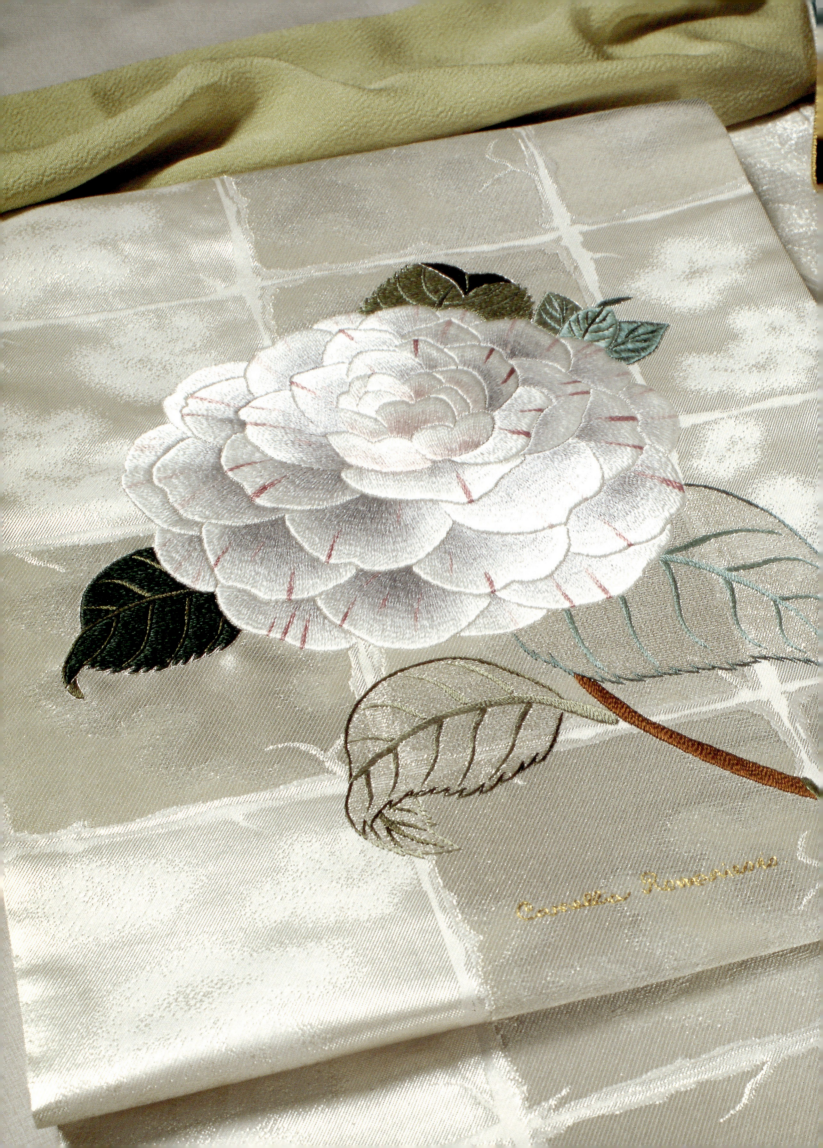

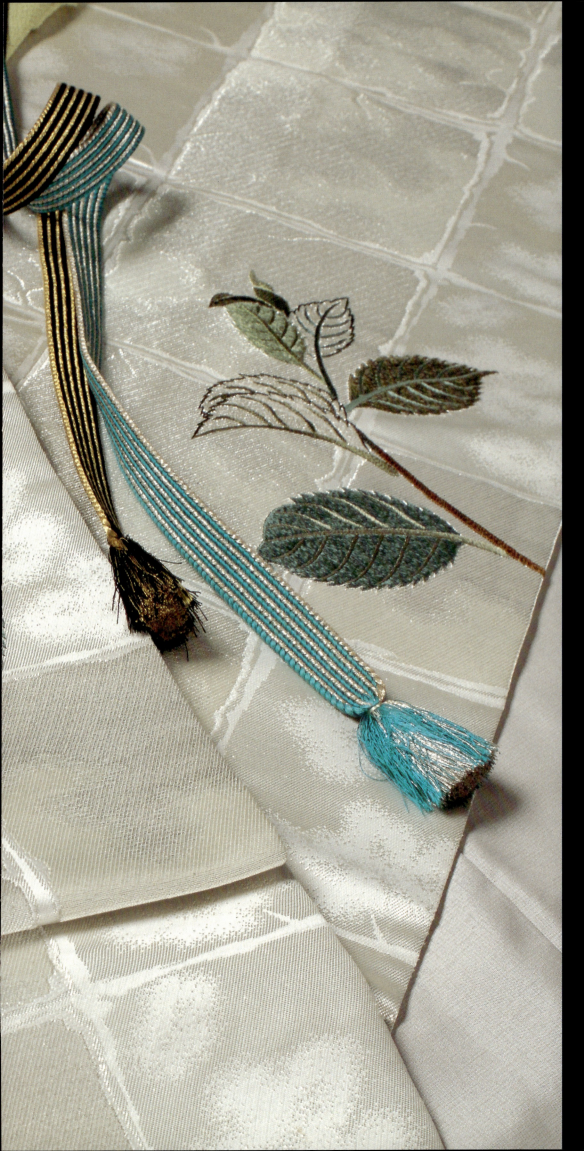

Double-Flowered Camellia

There are numerous varieties of camellia, and the double-flowered camellia is so gorgeous and has such a great sense of presence that I felt a single bloom would be adequate for this work. I chose white fabric as a base to represent a snowy background, then added a soft, subtle pink to the flower in order to achieve a crisp, yet gentle result.

Bamboo and Camellias

The image of a garden in the snow expressed through bamboo and camellia flowers is a traditional and popular motif. For Japanese people, green bamboo leaves that survive the winter and camellias that bloom regardless of the cold stand as symbols of nature's life force.

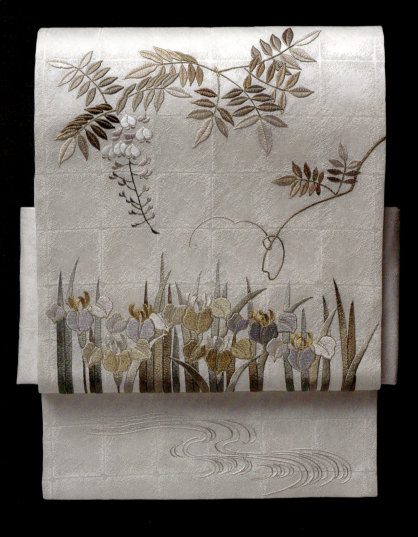

Wisteria and Irises

In this design, the wisteria expresses the pleasant spring breeze and the irises the warming of water in May. I left a space between the wisteria and the irises in order to create a kind of atmosphere.

Irises and Fireflies

This design shows fireflies over irises growing on a riverbank, embroidered on gradated indigo fabric. In the dark blue of gathering dusk, the light of the fireflies shines whitely on the water's surface.

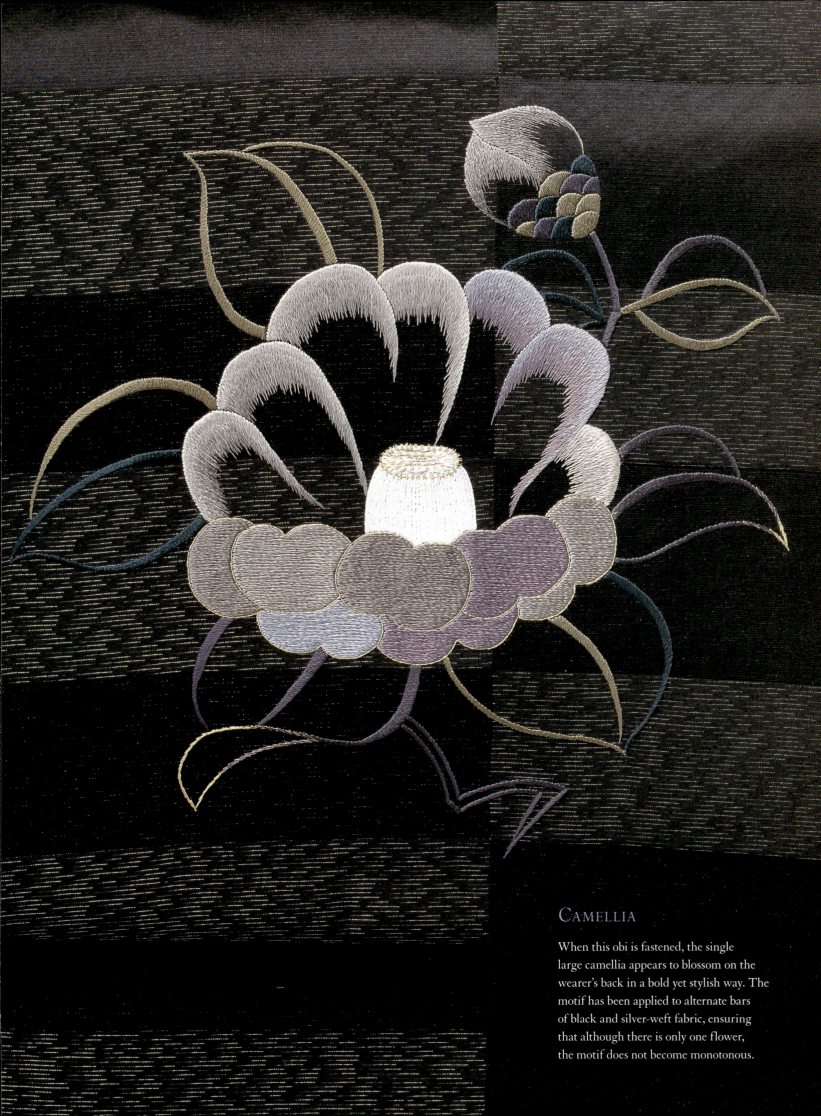

Camellia

When this obi is fastened, the single large camellia appears to blossom on the wearer's back in a bold yet stylish way. The motif has been applied to alternate bars of black and silver-weft fabric, ensuring that although there is only one flower, the motif does not become monotonous.

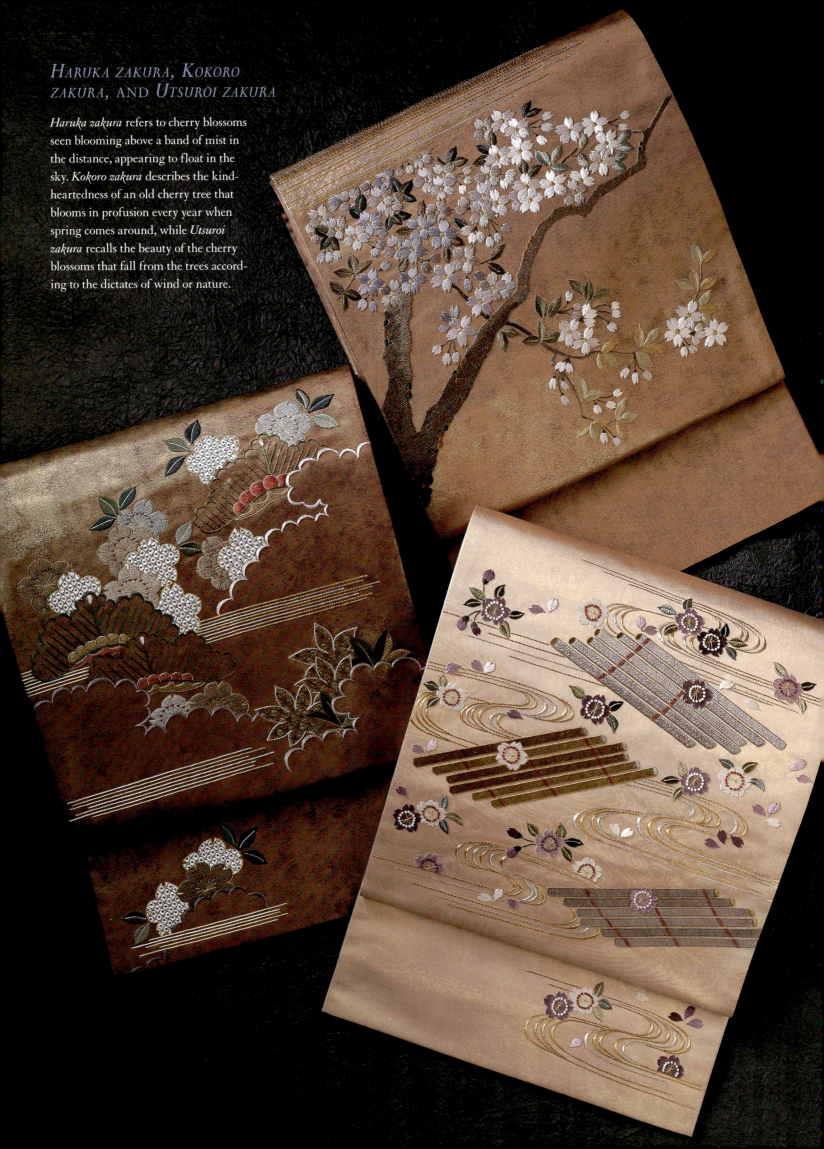

Haruka zakura, Kokoro zakura, and Utsuroi zakura

Haruka zakura refers to cherry blossoms seen blooming above a band of mist in the distance, appearing to float in the sky. *Kokoro zakura* describes the kindheartedness of an old cherry tree that blooms in profusion every year when spring comes around, while *Utsuroi zakura* recalls the beauty of the cherry blossoms that fall from the trees according to the dictates of wind or nature.

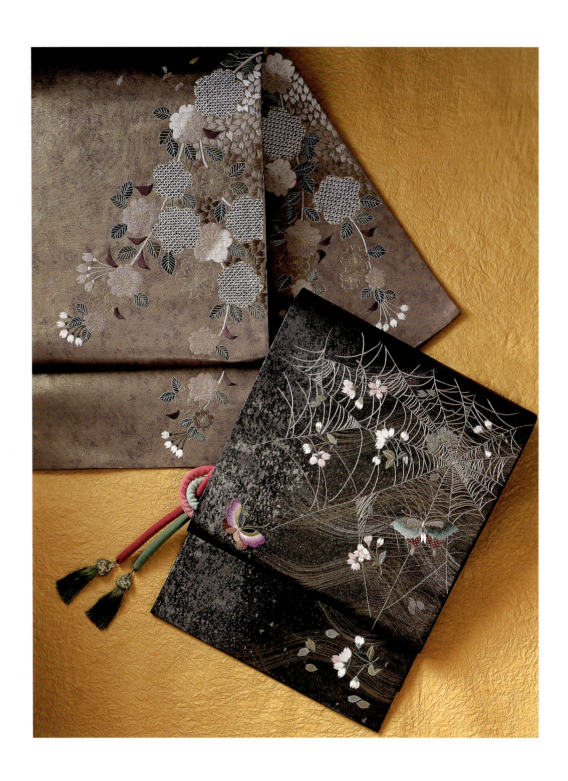

Usuzumi zakura and Kuon zakura

The term *Usuzumi zakura* (gray cherry blossom) comes from a work by the Heian period poet, Kantsuke no Mineo, that appears in the *Kokin wakashū* ("Collection of Ancient and Modern Poems," c. 914). In it he grieves the death of a friend and asks a cherry tree if it would bloom in grey, the color of mourning, that year. *Kuon zakura* refers to a poem by Sakanoue no Iratsume (c. 695–c. 750), who outlived three husbands, in which she writes that love is an ephemeral thing and I likened her emotions to the cherry blossoms.

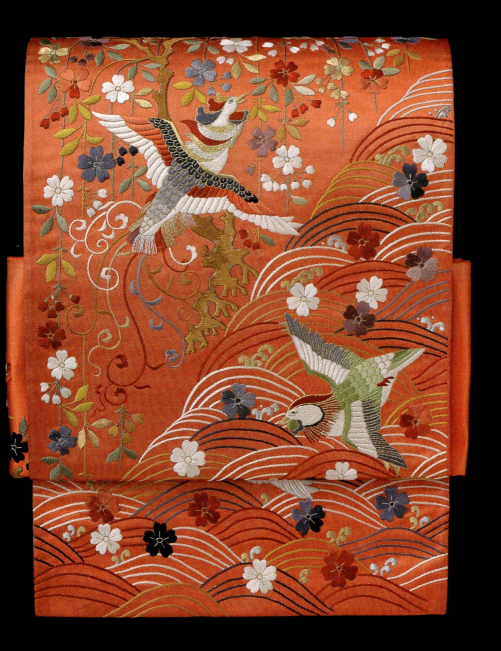

Ryūrei
Flowing and Elegant

I was so impressed by the embroidery of the first Nō costume I encountered that I decided to recreate it on an obi. This design of a phoenix, scattered cherry blossoms, a mandarin duck, and waves on red fabric is an elegant and classical design dating to the Momoyama period, and the waves and flowers have been laid out to create a feeling of balance. It possesses a timeless dignity and sophistication that serves to enhance the aura of the person wearing it.

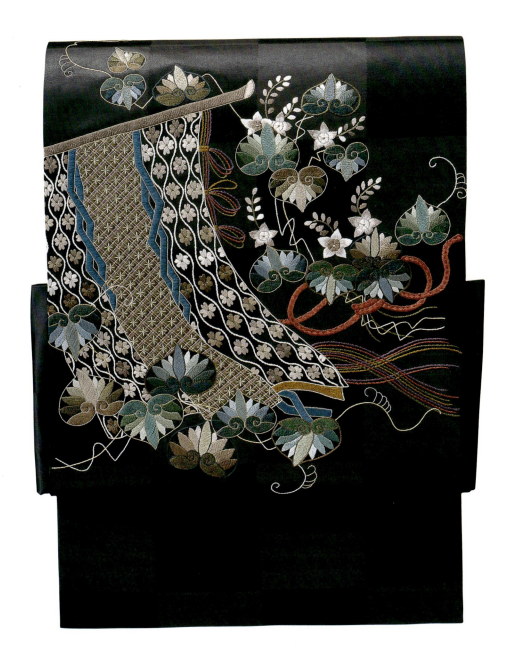

AOI NO UE

This design of cloth hangings and hollyhocks on glossy black fabric is based on chapter ten of *The Tale of Genji*, representing the image of Prince Genji's first wife, Aoi no Ue. A strong-minded and proud woman, she was unable to rescue their marriage after they became estranged from each other, and in her loneliness she hid herself behind a cloth hanging.

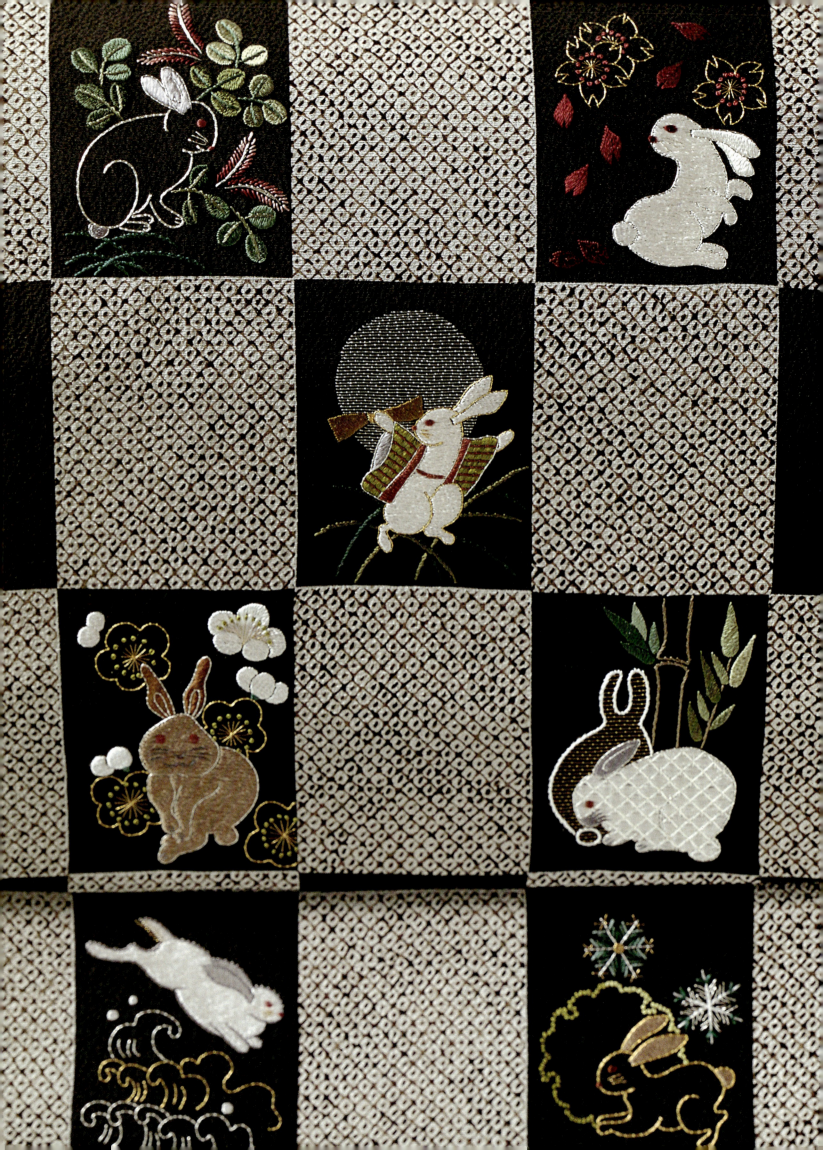

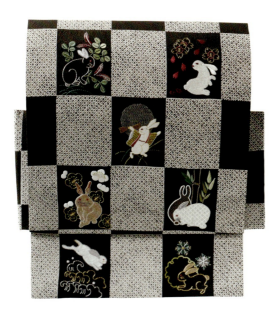

Usagi no dansu
Dance of the Rabbits

By embroidering various rabbits on the black sections of checkered *shibori* kimono fabric, it has been transformed into a pretty obi.

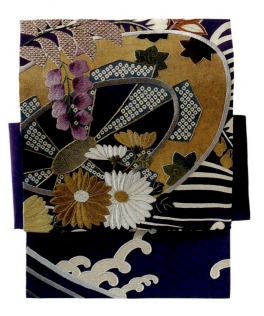

Hana yūzen
Yūzen-Dyed Flowers

I used fabric from an old kimono to make this obi. The dyed motifs of chrysanthemum and wisteria have been filled with silken embroidery threads, creating a feeling of depth and sheen to make the pattern stand out more clearly.

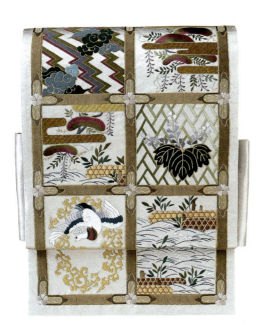

Coffered Ceiling

A lattice design, based on the coffered ceilings seen in temples or castles, has been filled with landscapes and motifs commonly seen on Nō costumes embroidered on silver figured brocade.

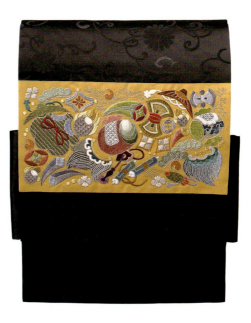

Assorted Treasures on Black

In order to add color and interest to a black obi, I applied a strip of golden-brown fabric embroidered with assorted treasures.

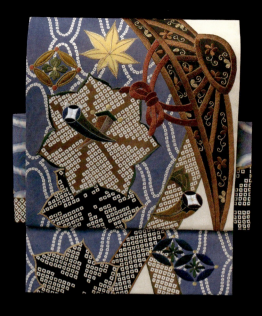

Hat with Assorted Treasures

This obi had a bold motif of a hat on brightly dyed *hitta shibori* patterned fabric, but being old, it suffered from a certain degree of wear. The addition of embroidered assorted treasures both gave new life to the obi and also created points of interest.

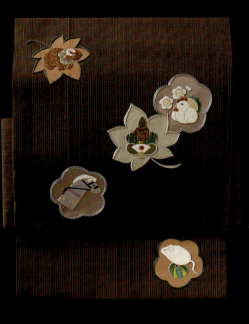

Floral Appliqué

This obi has been decorated with floral appliqués embroidered with animals from the Chinese Zodiac.

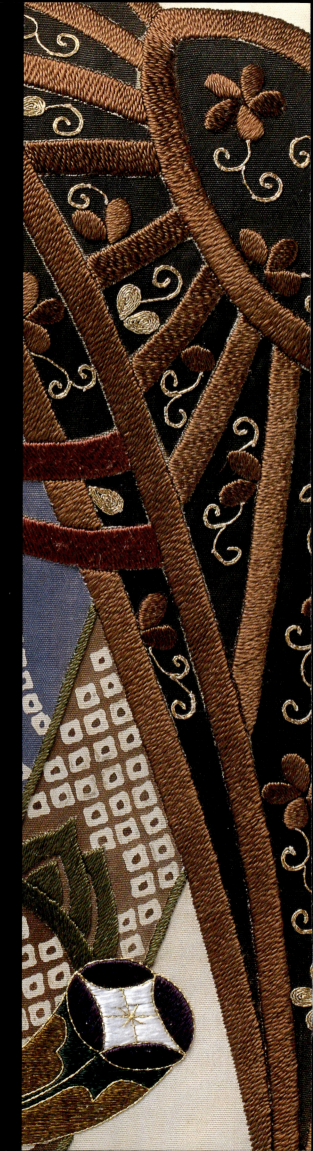

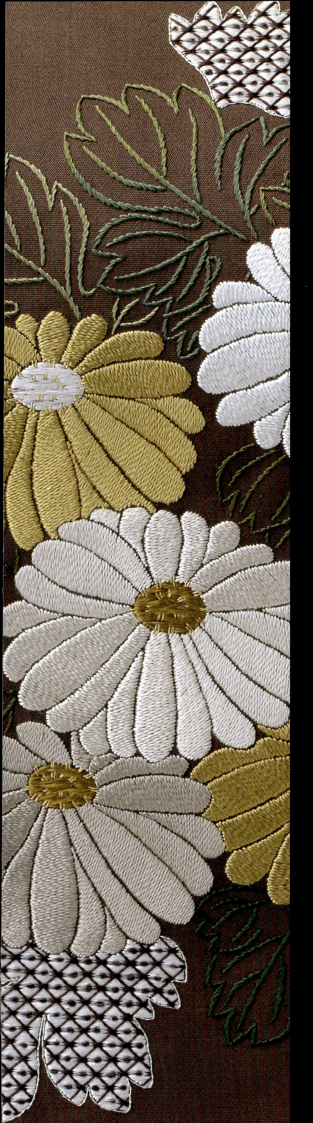

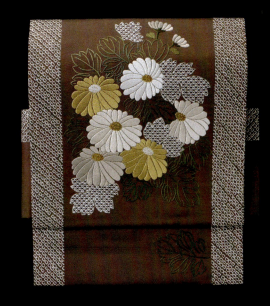

Chrysanthemums

The gentle texture of *hitta shibori* fabric combines with the volume of the flowers and subdued colors to express the dignity of the chrysanthemums in this design.

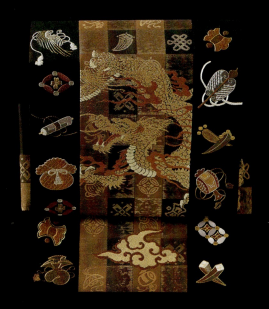

Yorokobi
Congratulations

An obi with a woven design of a dragon had motifs of assorted treasures applied to the black fabric on either side, thereby greatly increas-ing the impact of the piece.

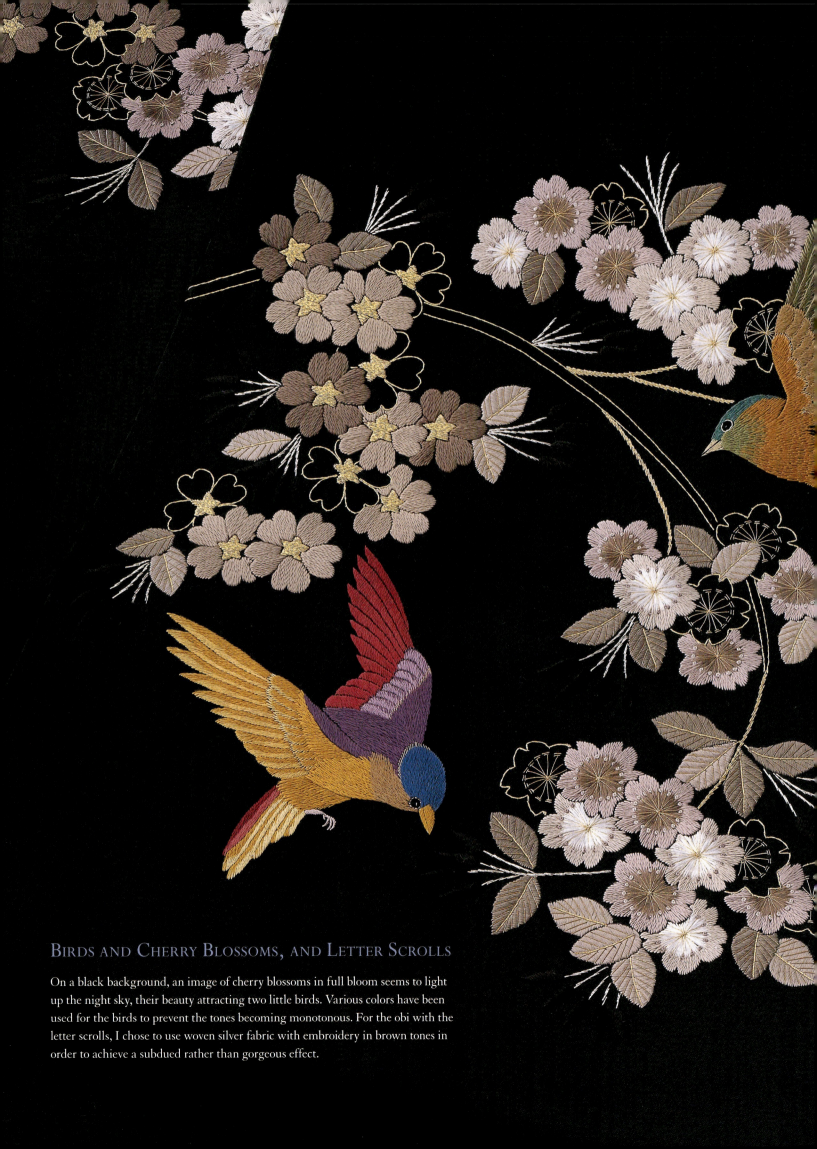

Birds and Cherry Blossoms, and Letter Scrolls

On a black background, an image of cherry blossoms in full bloom seems to light up the night sky, their beauty attracting two little birds. Various colors have been used for the birds to prevent the tones becoming monotonous. For the obi with the letter scrolls, I chose to use woven silver fabric with embroidery in brown tones in order to achieve a subdued rather than gorgeous effect.

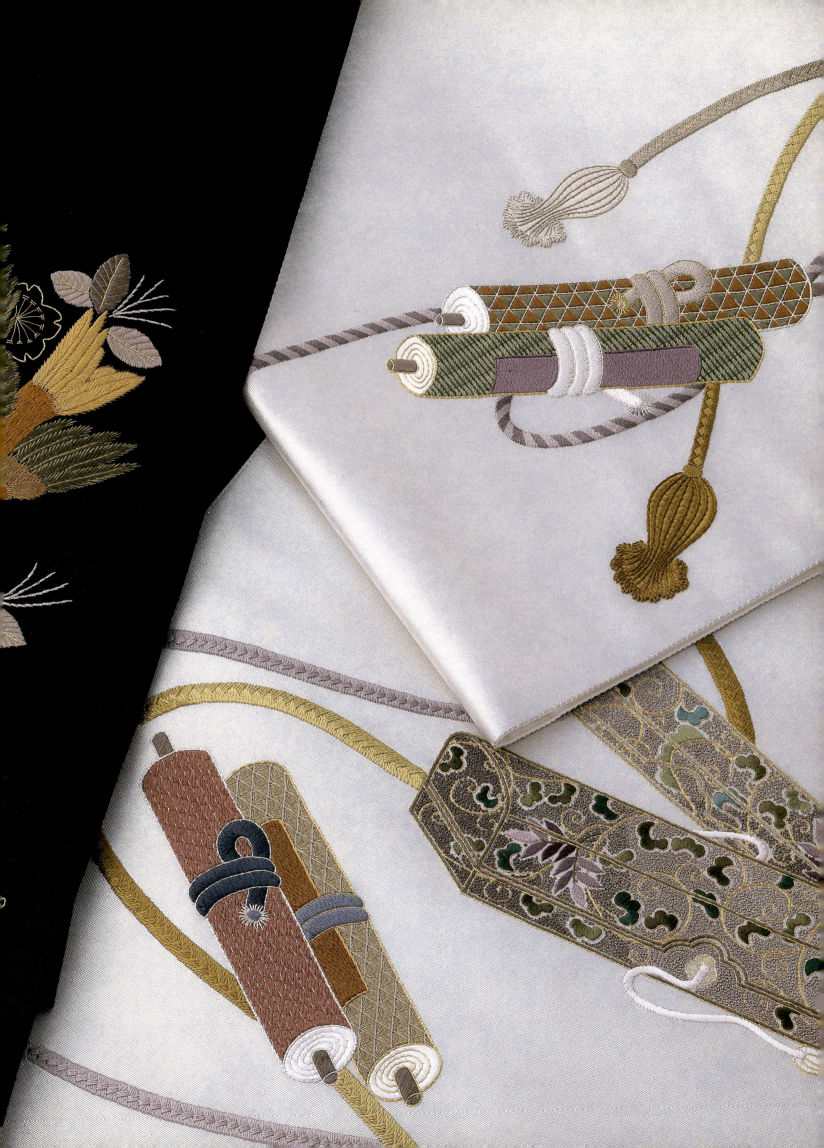

Fan Appliqué

I used the fabric from my father's old summer *hakama* (skirt trousers) to create a pre-tied obi that only needs clipping on. The gray color is rather muted for women's use, so I created appliqués of fans decorated with autumnal grasses, using different fabrics. It is pleasing to see the way the two different colored fans appear in combination when the obi is fastened.

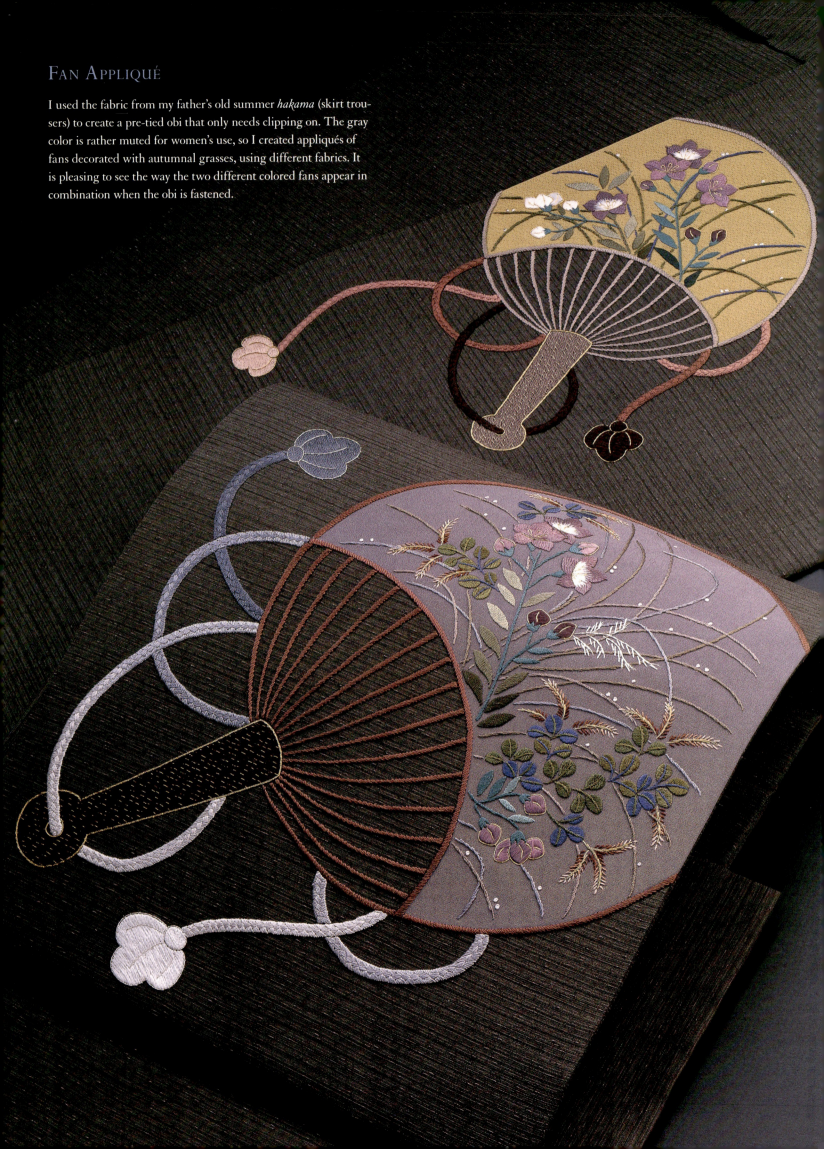

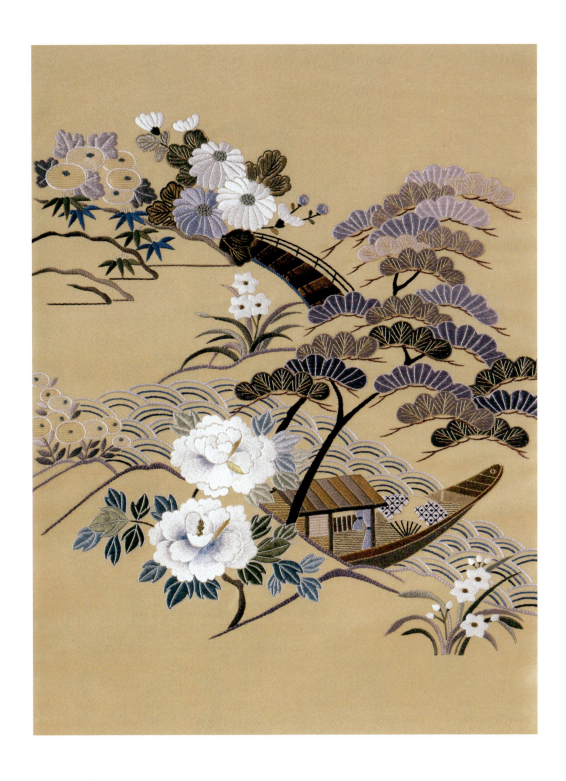

Shiigamoto
At the Foot of the Oak Tree

This is the title of chapter forty-six of *The Tale of Genji*, which concerns the beautiful sisters Ōigimi and Naka no Kimi, who live in a mountain village a boat ride across the Uji River from Kyoto. They worry about love and marriage, but even though advances are made to them they are unable to trust men's feelings. I have expressed the two princesses' complicated upbringing and personal anguish through quiet colors.

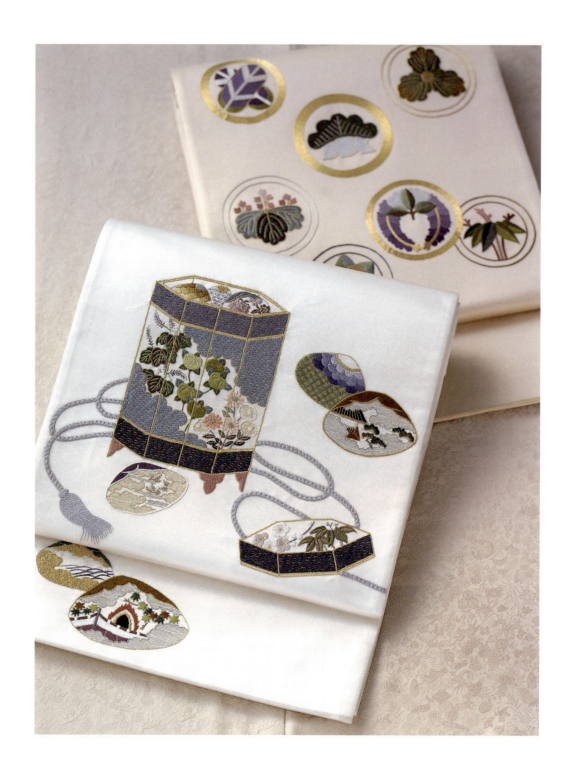

SHELL BUCKET AND FAMILY CRESTS

The design of the shell bucket has been embroidered on silver cloth, while the family crests are on woven gold fabric. Shell buckets are hexagonal, decorated lacquer containers for storing the clam shells used in the popular shell-matching game first played in the Heian period. In this game, each half of a clam shell is inscribed with the beginning and end of a 32-syllable poem, or alternatively each half of the pair is painted with an identical motif. The shells are placed upside down on the floor and the players take turns trying to find the pairs that match. This motif is considered a lucky one and may be used singly or in combination with others.

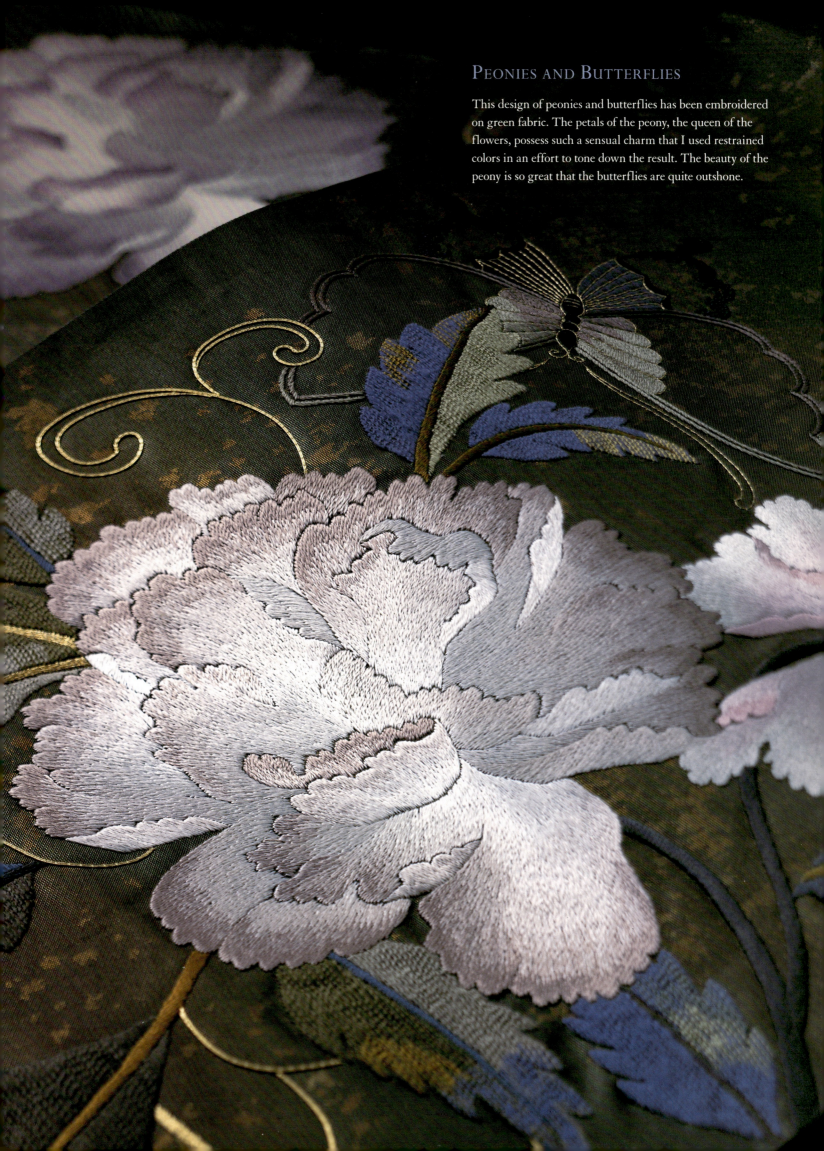

PEONIES AND BUTTERFLIES

This design of peonies and butterflies has been embroidered on green fabric. The petals of the peony, the queen of the flowers, possess such a sensual charm that I used restrained colors in an effort to tone down the result. The beauty of the peony is so great that the butterflies are quite outshone.

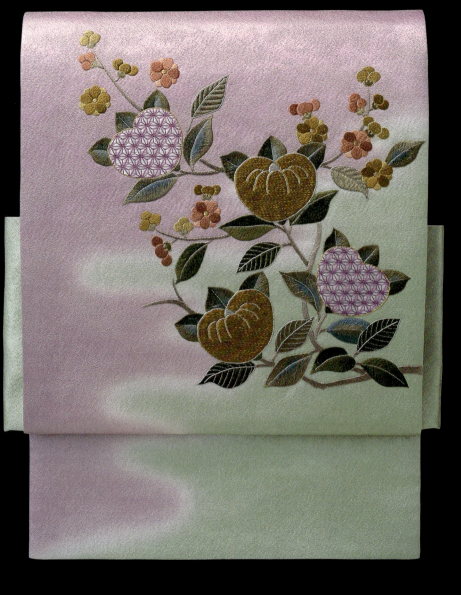

Hanachirusato

One of the characters in *The Tale of Genji* is Hanachirusato, a woman with a generous, motherly disposition. This design of a mandarin orange tree on gradated mauve and green silver-wefted fabric reflects one scene in which Prince Genji reminisces with her while the air is filled with the scent of orange blossoms.

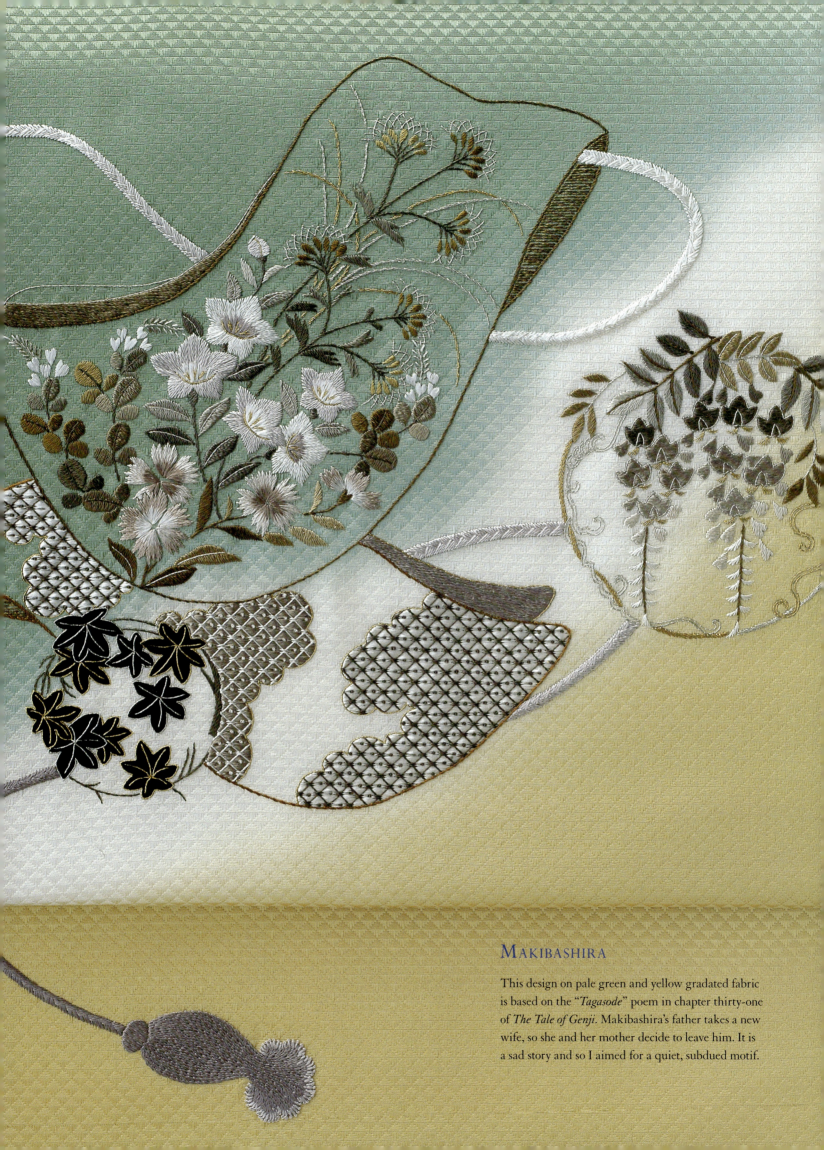

Makibashira

This design on pale green and yellow gradated fabric is based on the "*Tagasode*" poem in chapter thirty-one of *The Tale of Genji*. Makibashira's father takes a new wife, so she and her mother decide to leave him. It is a sad story and so I aimed for a quiet, subdued motif.

TAPESTRIES

INOCHI NO INORI
The Prayer of Life

In this work, blue represents the sky, green the planet Earth, and pink the gentleness of spring. The flowers come into bud and bloom magnificently, while the birds and insects all shine with the colors of life. Nature teaches us the importance of life and this is the concept I have tried to capture in this work.

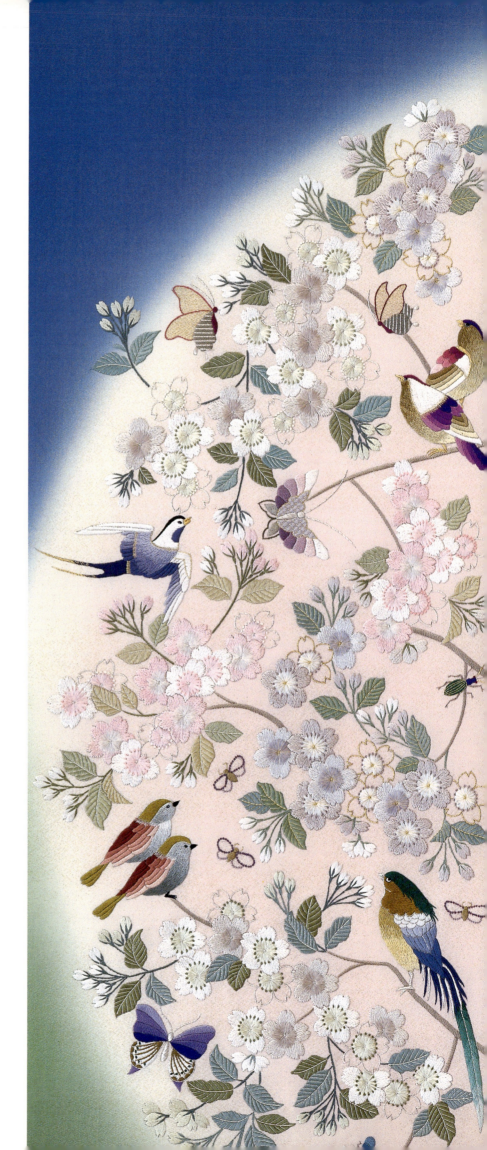

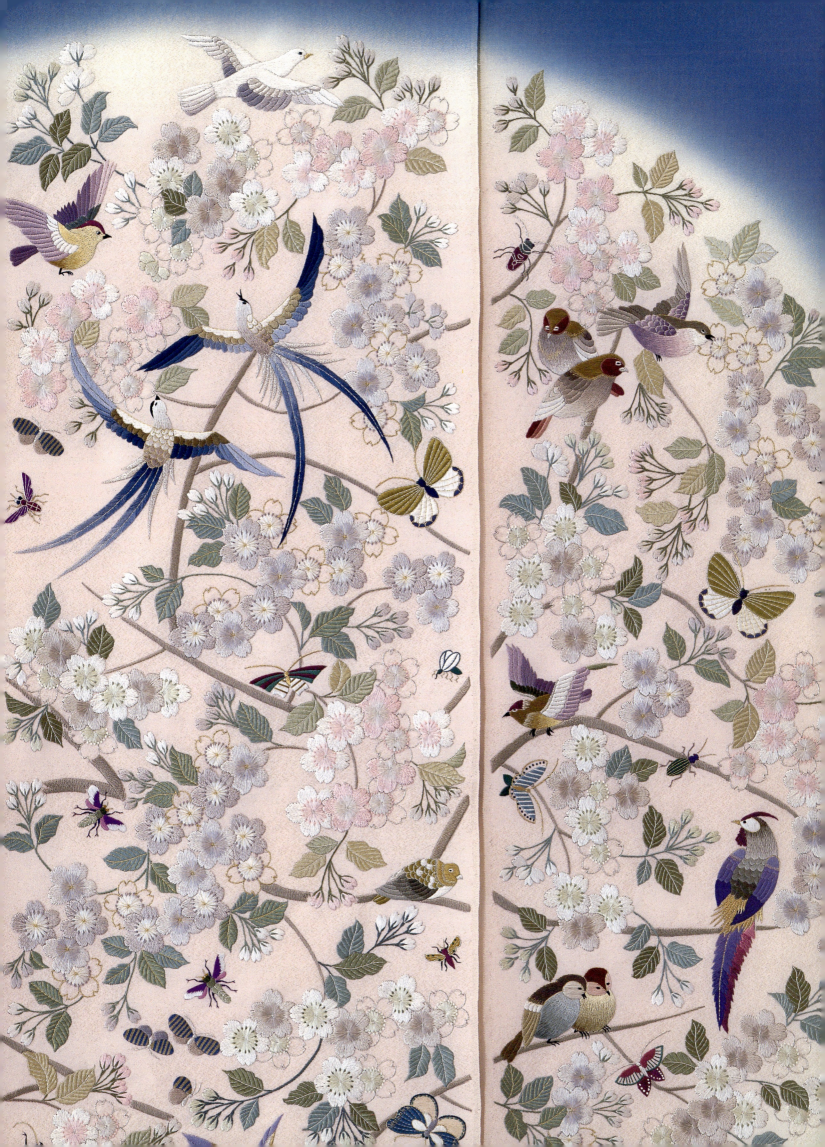

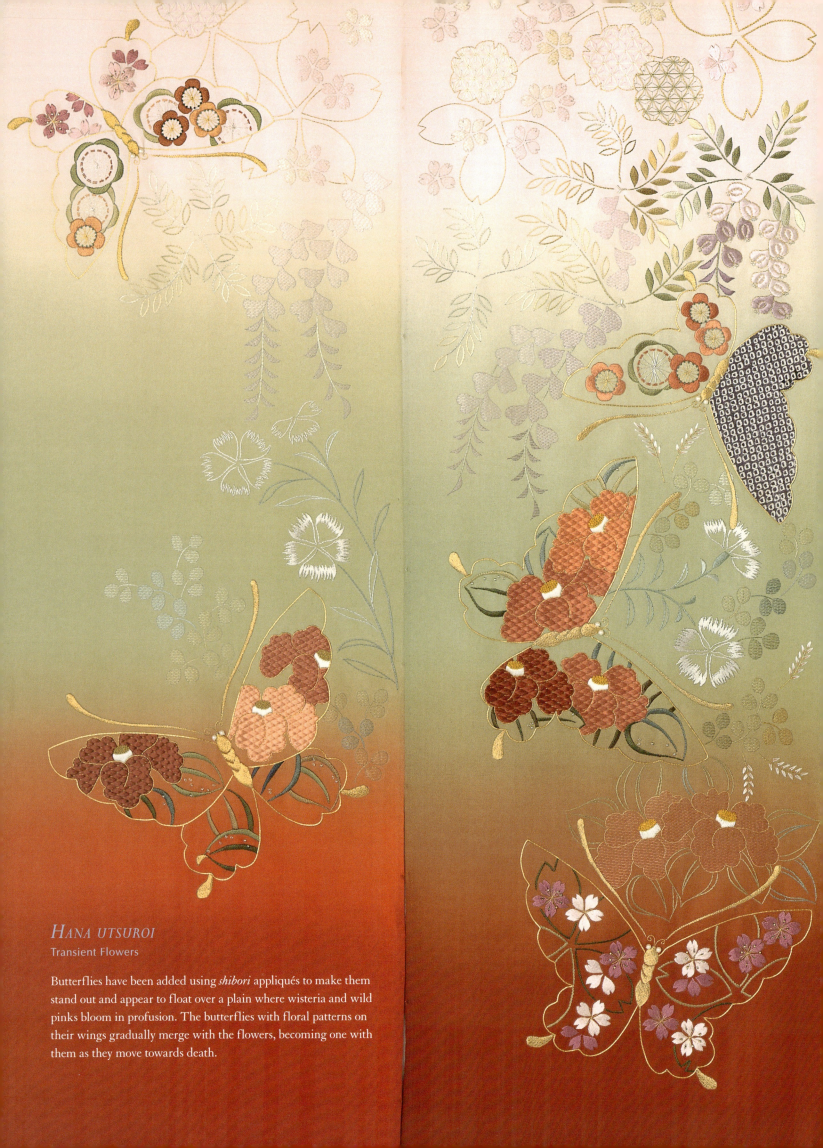

Hana utsuroi
Transient Flowers

Butterflies have been added using *shibori* appliqués to make them stand out and appear to float over a plain where wisteria and wild pinks bloom in profusion. The butterflies with floral patterns on their wings gradually merge with the flowers, becoming one with them as they move towards death.

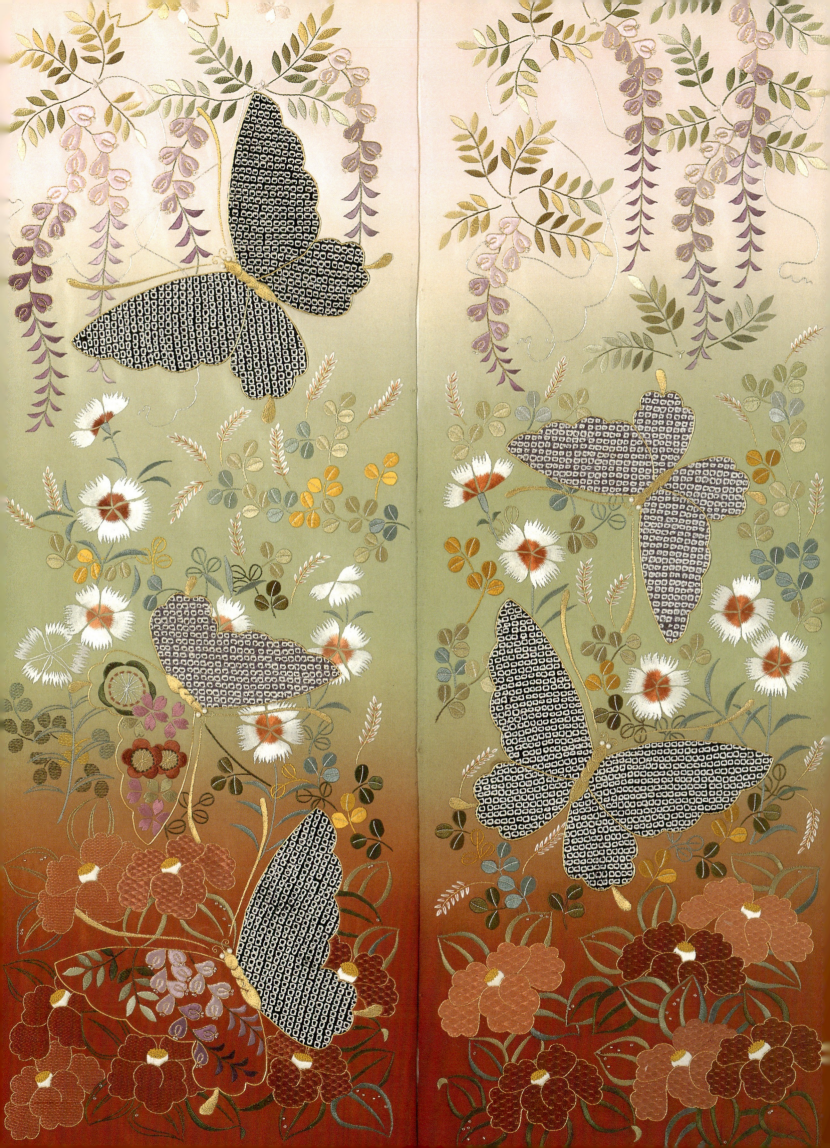

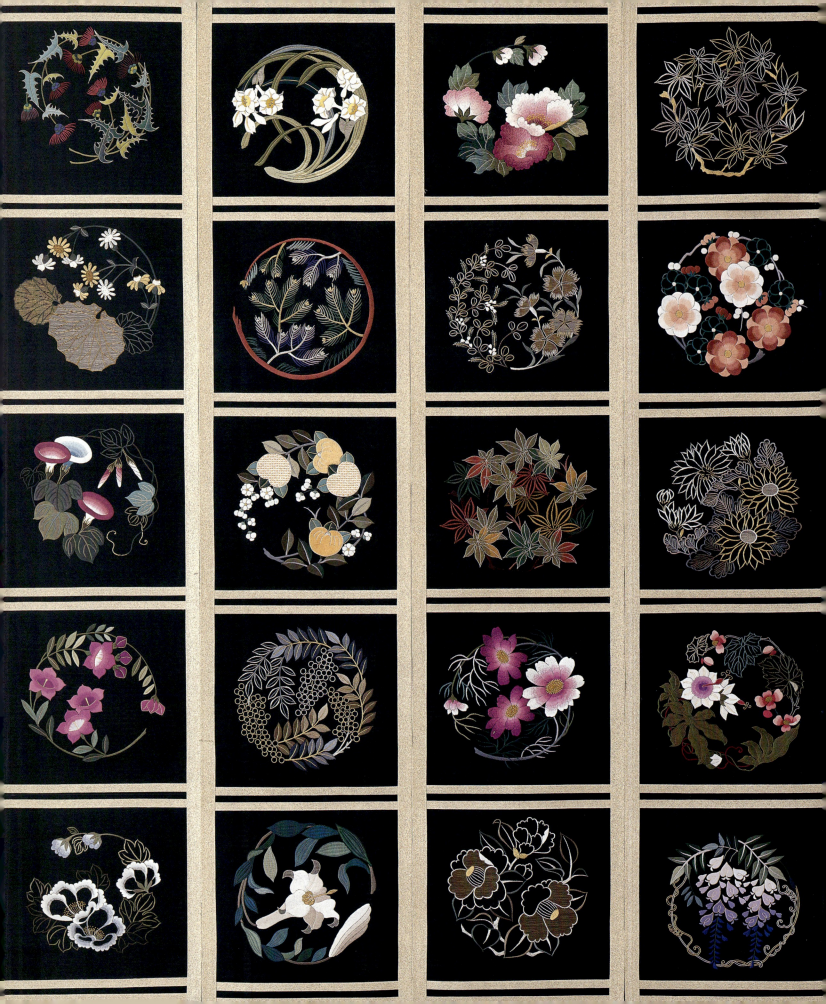

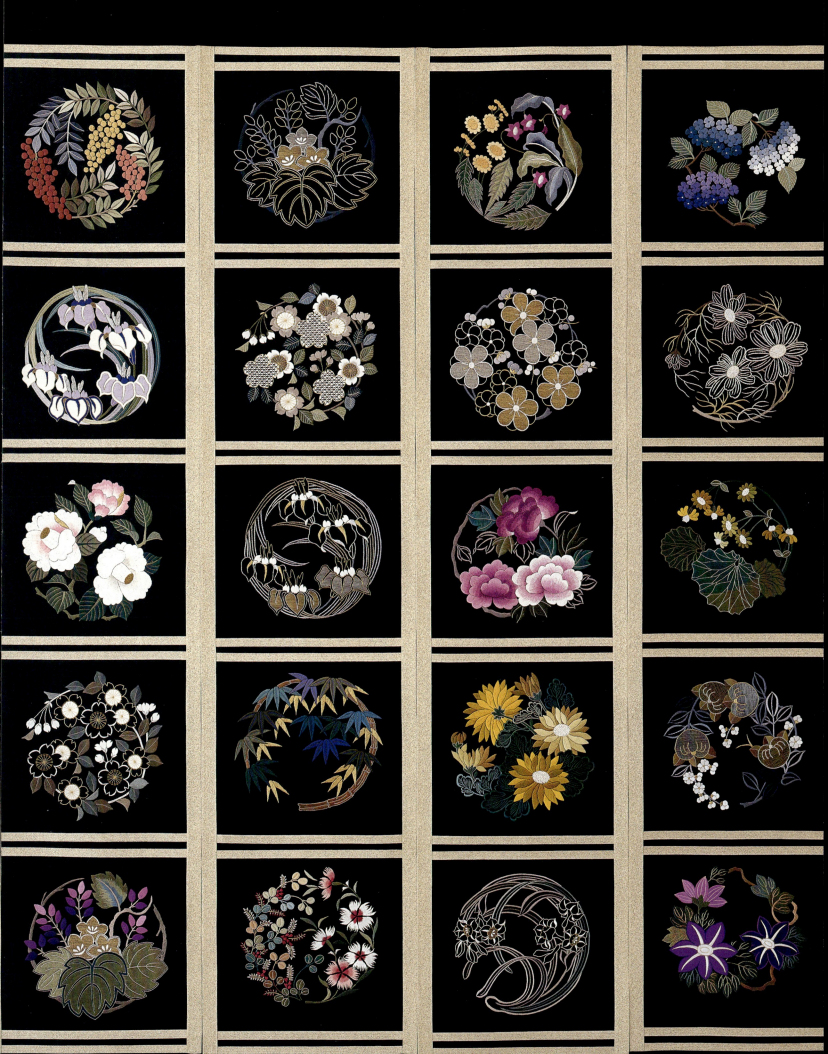

KAMON
Floral Motif

Japan's seasonal trees and flowers have been arranged in circular motifs and placed within a framework based on the coffered ceilings seen in castles or temples. This design expressing the dynamism of the living plants within a geometric pattern is typically Japanese, and is used not only for kimono or obi but also for ceramics and interiors.

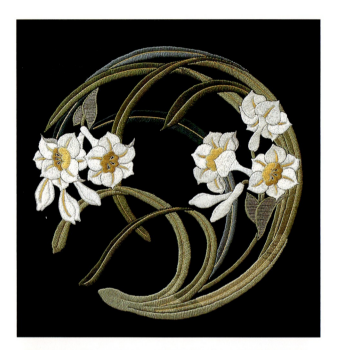

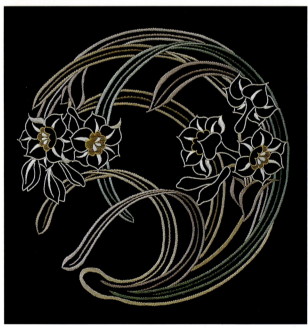

Details of *Kamon* showing two contrasting motifs of daffodils (above).

Detail of *Kamon* showing a motif of a cotton rose (right).

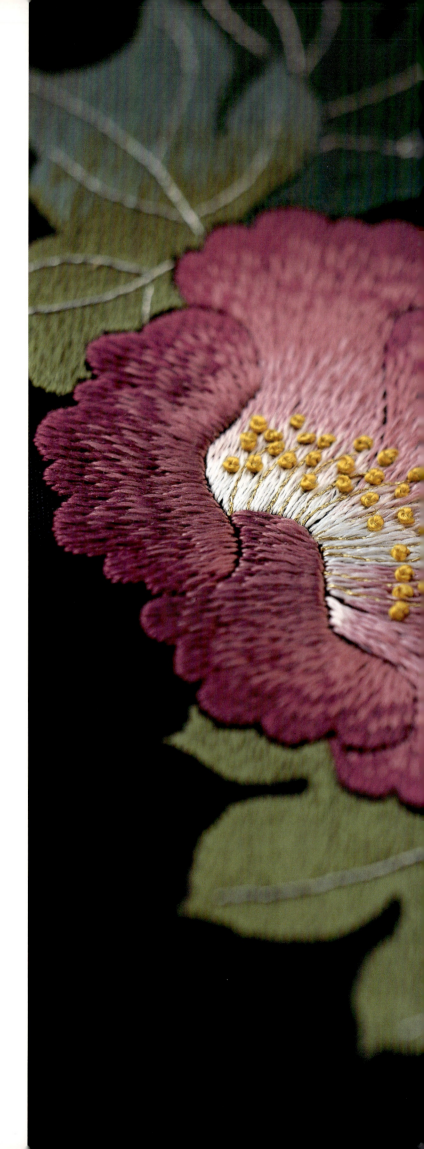

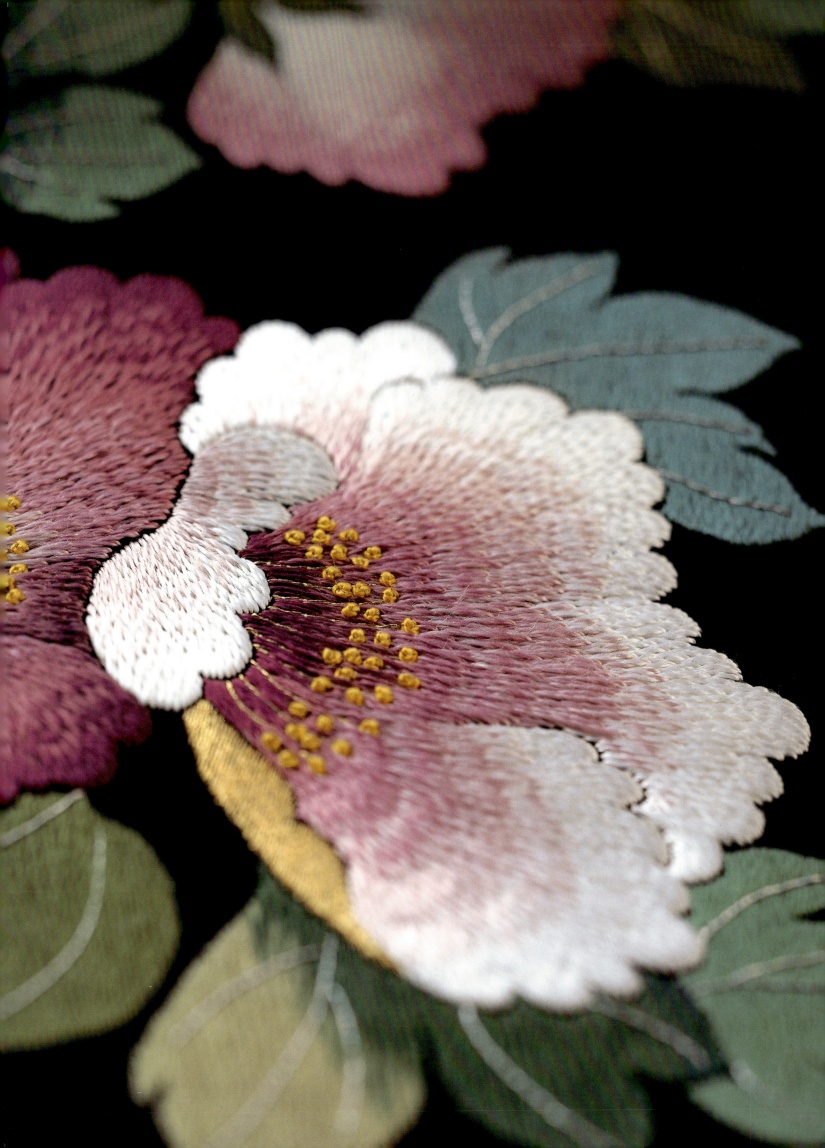

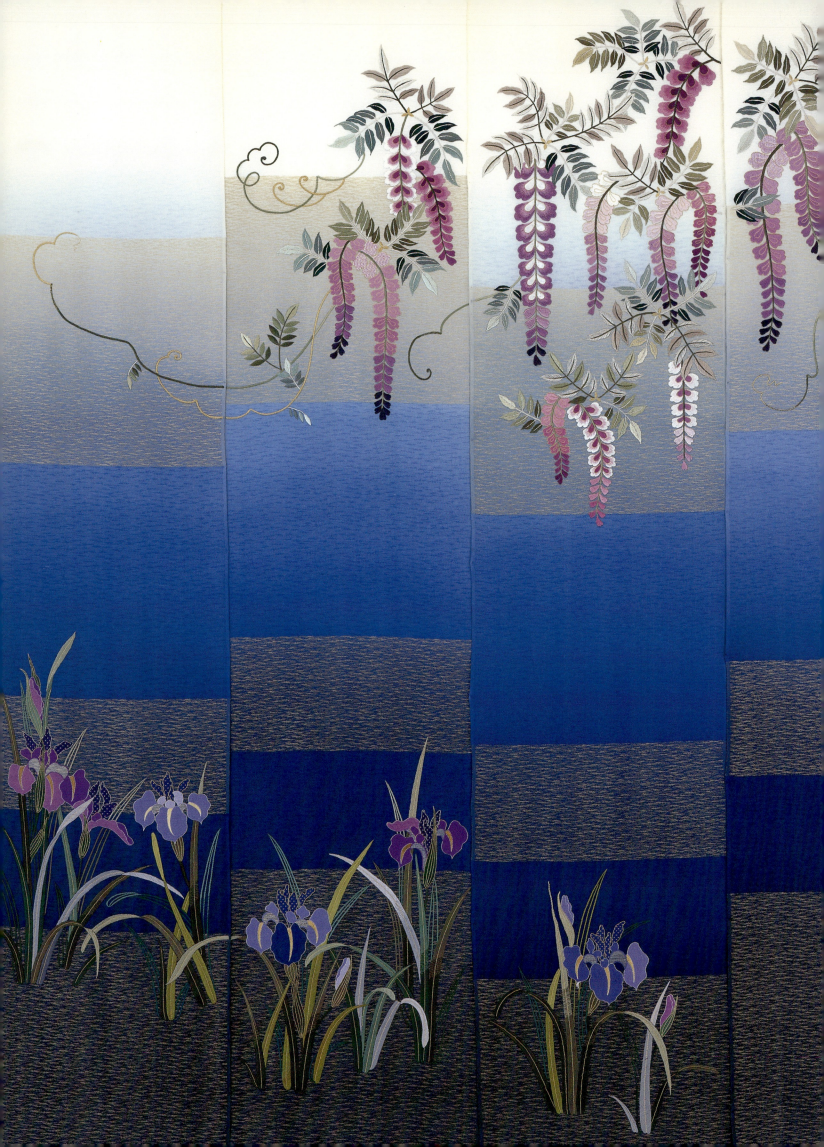

Kunpū
Balmy Breezes

This tapestry has a design of wisteria and irises. Gold-wefted fabric was dyed in gradated bars of blue, then the top half embroidered with a design of wisteria blowing in the wind and the bottom half with irises growing in water. The image of the flowing water was achieved by placing the bars of blue gradation at alternating levels.

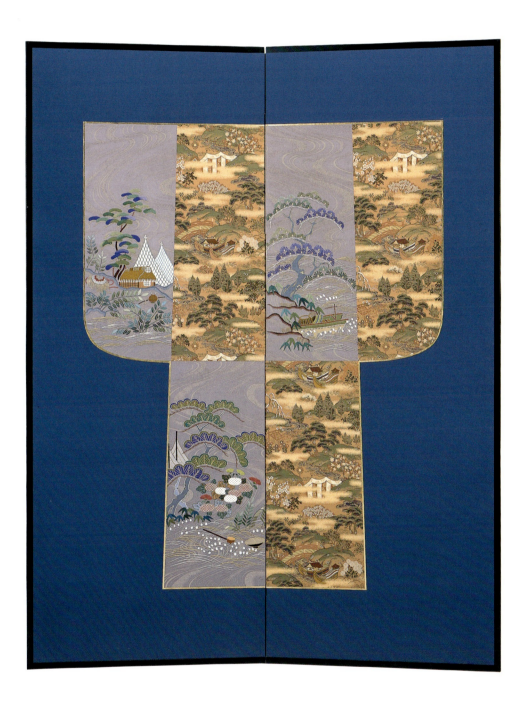

Matsukaze
Wind in the Pines

This embroidery contrasts two motifs of a seashore with pine trees, one dating from the Heian period, the other from the Edo period. Combined with gold leaf fabric originally woven for obi, it has been arranged to resemble the kind of parti-colored robes used in Nō costumes.

The History of Japanese Embroidery

Asuka Period (552–645)

Embroidery was initially introduced into Japan from China together with Buddhism. When Buddhism arrived in the country during the first half of the sixth century, it led to strife between those who supported traditional Shintō worship and those who accepted this new religion that came from the most advanced country in the world at that time, China. Eventually, after a period of political chaos, the supporters of Buddhism triumphed, creating a national policy that protected the new faith. This period is known as the Asuka period and it lasted from the mid-sixth to mid-seventh centuries; it was a time that witnessed a blossoming of formative arts connected with Buddhist worship, including embroidery, with large numbers of embroideries being imported from the continent as well as produced domestically. The majority of these were embroidered images of Buddha, which were worshiped in much the same way as gilt bronze statues, or served in a subsidiary role to the central image in temples. There are records of a *jōroku* (16 ft) embroidery of Buddha being created, and the scale of this work would seem to indicate that embroidery technique was already quite advanced at this point in time. There are many possible reasons why embroidery should have been used to create this work rather than a painting, but it was probably due to the structure of the temple for which it was made, or in order to achieve a particular visual effect.

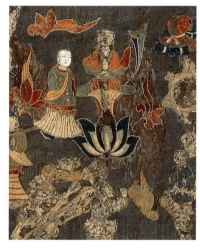

Tenjukoku shūchō
Asuka period, 7th century
Chūgūji Temple, Nara prefecture

A work dating from this period that remains intact to this day is the *Tenjukoku shūchō* ("Land of Heavenly Longevity Mandala"), which is embroidered on silk and depicts Buddha sitting on a lotus, together with priests, Chinese phoenixes, floating clouds, and arabesque scrolls. Although the picture appears somewhat disjointed, this is due to the fact that it became damaged over time and the surviving fragments were combined to create a single hanging, so there is no way now of telling what the original design was. It is said that when Prince Shōtoku died, his wife was most upset and pleaded with the emperor to create a memorial to him. He granted her request and issued an imperial command to create this tapestry, the work being carried out

by the ladies-in-waiting. The techniques used in its creation include *kaeshinui* (back-stitch), *matsuinui* (running stitch), *jibiki* (weft layer stitch), *sashinui* (shading stitch), and so on. *Kaeshinui* is performed by passing the needle up from beneath the base fabric, then, having made one stitch, returning halfway back to the original position and making the next stitch from there, creating a continuous chain of overlapping stitches. This is a basic embroidery technique that can easily be accomplished by amateurs, so it is likely that the court ladies did indeed work on it.

Nara Period (710–794)

Quite a number of embroideries dating to the Nara period remain to this day. Among the artifacts belonging to Emperor Shōmu that were stored in the Shōsōin repository are numerous works of art, many of which originated on the continent. These include several examples of embroidery that deserve our attention today. One is entitled *Kaju kujaku monyō shishū* ("Tree, Flower, and Peacock Pattern Embroidery") and depicts a single peacock walking graciously through trees and flowers, using *kaeshinui* and *jibiki* in shades of white, yellow, green, purple, and red to create designs on both sides of the fabric. The fact that the design can be seen from both sides would seem to indicate that it was used as a banner, or something similar. The majority of embroideries remaining in the Shōsōin utilize threads with a light twist to perform the *jibiki* stitches, creating rich, evocative depictions of flowers, birds, and trees. In both technique and design, these Nara-period embroideries embody the vigor and brightness of the Chinese Tang-dynasty culture (618–907), which had recently supplanted that of the Sui dynasty.

Heian Period (794–1185)

The historic background of this period differed greatly from that of its predecessor. Tang-dynasty China was the most advanced country of its time and had long stood as a model for Japan, but fell into decline and was finally overthrown in 907, losing forever its position as a world empire. In 894, the Japanese ceased their custom of sending diplomatic missions to China on a regular basis to study the culture there, with the result that the dominant influence of China on Japan waned, allowing the Japanese to develop their own native form of aesthetics and culture.

The Heian period also saw a change in the form of embroidery that was produced. Gone were the embroidered pictures of Buddha, as painting became accepted as the ideal medium for this kind of work. Instead, embroidery began to be used to add areas of decoration to clothing, although few examples of these remain to this day. With the development of a uniquely Japanese culture during this period, a new form of court dress appeared, the *sokutai* style for men and *jūnihitoe* (multilayered kimonos) for women. With the *jūnihitoe*, the inner garments were covered by the outer ones, so however beautifully a robe may be embroidered, the effect would be wasted. As a result,

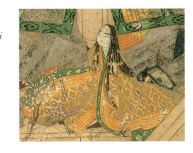

Detail from *Genji monogatari emaki* showing a woman wearing a *jūnihitoe*.
Heian period, 12th century
Tokugawa Museum, Aichi prefecture

embroidery was limited to the collars, cuffs, and hems of the garments, where the combinations and contrasts of colors could be truly effective. According to records from this time, the ladies of the court applied embroidery to their outermost garments as well as the edges of their inner robes.

Kamakura and Muromachi Periods (1185–1573)

During the Kamakura period (1185–1333), political control of the country shifted from the nobles to the warriors. The period saw a revival in the creation of embroidered pictures of Buddha, which had dropped out of favor during the Heian period. This was due to the spread of the eschatological philosophy known as *mappō*, with people believing that Buddhist law would degenerate and vanish, and that their hearts would be thrown into turmoil. They turned their backs on mundane affairs and, striving to achieve happiness in Paradise, they prayed to Amida Buddha for salvation. In order to be reborn in the Pure Land, people believed that they must earn merit while they were on Earth and, depending on their caste, rank, and wealth, they built temples, pagodas, commissioned Buddhist statues, or copied the sutras. The embroidery of Buddhist images or banners was considered one way of gaining merit and was carried out in great earnest. As a result, large numbers of embroidered Buddhist images are said to have been created and, among those that remain today, some display a high degree of technical excellence and were probably the work of specialists, while others appear rather amateurish.

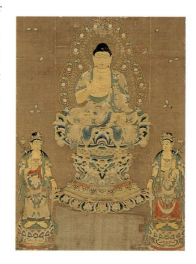

Shishū Amida sansonzō
Kamakura period
Sainenji Temple, Ishikawa prefecture

A representative work of Kamakura embroidery is the *Shishū Amida sansonzō* ("Embroidery of the Amida Triad"). This embroidery was created using extremely fine threads of indigo, blue, green, purple, red, and yellow, the outline being applied in *kaeshinui*, while the surfaces of the figures are embroidered using *sashinui*.

Momoyama Period (1573–1615)

The Momoyama period extends for forty-two years from the time that Oda Nobunaga (1534–82) overthrew the Ashikaga Shogunate in 1573. Following his death, the brilliant general Toyotomi Hideyoshi (1536–98) took over the reins of power, unifying the country and building a castle in the Momoyama district of the capital, Kyoto. This marked the end of the civil wars of the preceding centuries and the beginning of the pre-modern feudal period. It was a time that saw new leaders emerge, and a time of openness reflected in the bright, unconstrained arts that were produced then.

The Momoyama period was a particularly important one in the history of textiles. The *kosode*, a new form of clothing that had appeared at the end of the Muromachi period, was widely adopted while the popularity of Nō theater led to new developments in fabric decoration for the costumes. Three techniques—*nuihaku*, literally "embroidery and foil," combined embroidery with imprinted gold or silver leaf; *surihaku*, literally "rubbed metal foil," involved impressing metal foil onto fabric on

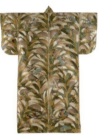

Yukimochiashi ni suikin monyō nuihaku
Momoyama period
Hayashibara Museum of Art, Okayama prefecture

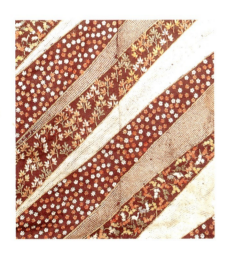

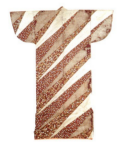

Nuishibori kosode
Momoyama period
Tokyo National Museum

which a design had been applied in paste; and *shibori zome*, a term that covers a variety of tie-dye techniques—were combined with the new form of clothing to create the *keichō kosode*, a marvelous example of the weaver's and dyer's crafts. If we look at these developments from the viewpoint of embroidery, it can be seen that this ceased to be merely a technique to add small points of interest to a garment or a tool to express religious devotion, and had become a form of aesthetic expression appreciated for its own innate qualities. No longer limited to creating a motif, embroidery was used to heighten the effects created by gold or silver foil or *shibori zome*, while also being treated as something with an inherent value of its own.

Let us look now at one of the most famous *nuihaku* works, the *Yukimochiashi ni suikin monyō nuihaku* ("Snow-covered Reeds and Waterfowl") in the Hayashibara Museum of Art in Okayama prefecture. The entire area of the fabric is covered with a design of snow-covered reeds with an occasional waterfowl, while the spaces in between have been filled with gold and silver foils. This gorgeous *kosode* achieves a three-dimensional effect while demonstrating a skillful use of color, perfectly conveying the atmosphere of the period. We know that the embroidery techniques employed in its creation include *jibiki*, *sashinui*, and *matsuinui*.

A good example of a kimono in which *shibori zome* and embroidery have been used together to great effect is the *Nui shibori kosode* belonging to the Tokyo National Museum. It has a bold, innovative design that would not seem out of place today, with *shibori zome* and embroidery alternating to create diagonal stripes. The *shibori zome* technique used is called *kanoko shibori*, which creates a mass of tiny raised, spherical lumps in the fabric, and the embroidery was carried out to complement this, creating tiny designs of cherry blossoms, maple leaves and deer, and young pine trees in *sashinui* on a black base. *Komadori* (coaching) in gold thread was used for the borders between the *shibori zome* and embroidery.

The unconstrained, bright style of the Momoyama period was to continue into the Edo period, when Japanese textile culture reached its heyday.

Edo Period (1615–1868)

Peace reigned in Japan for over two and a half centuries during the Edo period, something almost unprecedented in world history. During this period of stability the economy developed in major cities, resulting in the birth of a highly developed culture that spread through every aspect of people's daily lives. The seat of government moved from Kyoto to Edo (present-day Tokyo), but the nobles and samurai ceased to be the cultural driving force, this role falling to the townsfolk, particularly the increasingly prosperous merchant class.

With regard to dyeing and weaving, a rich diversity of patterns and designs flourished throughout the Edo period as a result of the *kosode* becoming the universal style of dress regardless of rank or wealth. The use of embroidery in combination with *shibori zome*, *yūzen zome* (a kind of paste resist dyeing) and *surihaku* heightened the decorative effect.

Two of the best examples of the result achieved by using embroidery in combination with *shibori zome* are two *kosode* in the Tokyo National Museum, one with a pattern of fishing nets, Mandarin ducks, and waves on black-figured satin, the other with cherry-blossom-motif fans and a curtain on white satin-weave silk. The first of these is thought to have been created in the early Edo period and is in the *kanbun* style with the right half of the garment from the shoulder down the back covered in a large motif and the rest left largely unadorned. The fishing nets are depicted using red and indigo *shibori zome*, while the wave tops, waves, and mandarin ducks are embroidered in gold, red, indigo, light yellow, beige, and other threads. There is not much embroidery, but the balance between the black fabric, the red and indigo of the fishing nets, and the gold thread of the mandarin ducks and waves is quite exquisite, while the feeling of volume contributed by the embroidery creates a masterpiece that is bold yet not overstated.

The Edo period was also a time when women's obi changed radically. In addition to simply binding the clothes to the body, the obi served other important functions such as carrying swords or various other items, as well as being decorative. After the *kosode* had become the main form of dress, and particularly after the Kanbun era (1661–73), the length, width, and methods of tying the obi were standardized and, like the contemporary obi (1 ft x 13 ft), it became an independent garment in its own right, with a variety of fabric such as satin, figured satin, velvet, *karaori* (thick ornate fabric woven in a Chinese style), and brocade used in their production. Obi were decorated using *shibori zome*, *yūzen zome*, and embroidery to produce a huge variety of designs. Edo-period obi with embroidered designs such as irises and anchors on pale-blue figured satin or daffodils and puppies on red velvet may seem almost excessive by today's tastes, but they represent outstanding embroidery designs. The emblem of the anchor symbolizes a woman putting down strong roots with her new family after marriage, while the puppy motif refers to the popular belief that dogs whelp with no pain and therefore symbolize safe birth.

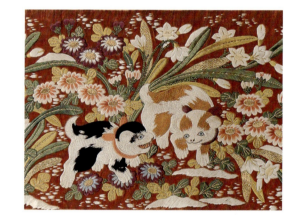

From the Meiji Restoration (1868) to the Present

After the collapse of the Edo government, the traditional quasi-independence of the feudal domains ended and a modern, Western-style nation state was born; this is known as the Meiji period (1868–1912). Western dress was adopted with remarkable speed, with civil servants and school teachers being ordered to wear Western clothing. Despite this, the everyday wear of the ordinary people remained virtually unchanged from the Edo period. According to the research of the ethnologist Wajirō Kon (1888–1973), even as late as 1925 ninety-nine percent of women walking in the exclusive Ginza area of Tokyo wore kimono while only one percent wore Western clothes (the same research shows that sixty-seven percent of men wore Western clothing). Being situated in the center of Tokyo, the fashionable Ginza area is hardly typical, so this data would seem to indicate that in the rest of the country, one hundred percent of women wore kimono in their daily lives.

Akabirōdoji suisen ni koinu monyō nui obi
Edo period
Tokyo National Museum

With regard to the kimono they wore, a major change occurred between the end of the nineteenth century and the mid-thirties or forties. This was a boom in *meisen* silk, a flat-woven fabric that was mass produced for the ordinary people. According to Wajirō Kon's 1925 survey, more than half the women seen in Ginza were wearing *meisen* jackets, kimono, or both. One of the reasons behind this boom was the increased visibility of women in society, with more of them entering the workforce and girls wearing *meisen* kimono to school. Another was that the silk could be mass produced using new machinery, bringing the price down to one that was affordable to the general public.

From the viewpoint of embroidery this was unfortunate, as it did not benefit at all from this *meisen* boom. There were various trends in fabric design, from striped in the Meiji period, to splashed patterns in Taisho (1912–26), and then dramatic, bold motifs in Shōwa (1926–89), but in *meisen* silk, the yarn is dyed before weaving and so embroidery became quite irrelevant.

If we take a look at the textile industry after the beginning of the Meiji period, what really stands out are the developments in mechanical engineering and the advent of electricity that led to rapid mechanization. The spinning of cotton or silk moved from hand to machine, the Jacquard loom cut down dramatically on the time needed to weave cloth, while chemical dyes made it possible to rapidly dye large quantities of cloth in clear, bright colors. In addition, woolen fabrics were imported and artificial fabrics were invented. Eventually the kimono gave way to Western clothing, and became looked upon as something special, only to be worn on special occasions. As a result, the patterns or embroidery on kimono became limited to those suitable for specific situations and the garment ceased to be the medium through which people could satisfy their desire to be chic.

However, over the last five or six years, we have witnessed an increasing willingness to reevaluate traditional Japanese culture. The beauty of Japanese art and traditional crafts has been rediscovered, while there is also a growing interest in kimono among young women. There are more opportunities to see women wearing kimonos, and appreciation of Japanese embroidery is also growing, albeit gradually.

Embroidery today no longer remains confined to kimono and obi, but is enjoyed on a variety of personal items. A painter once told me he was very jealous of me as an embroiderer. He explained that embroidery is able to utilize the sheen of the silk threads in a way that cannot be duplicated by paint, while its textures also create tonal variations that alter according to the angle from which it is viewed, adding a unique depth to the motif. This is quite true and a fascination with embroidery is gradually spreading. People are exchanging their paints for yarns, their brushes for needles, and are using a variety of fabrics for their canvases. Tablecloths, handkerchiefs, bags—people enjoy applying their own visions to a variety of personal items through embroidery, and this, I think, will be the future of embroidery in this country.

My First Encounters with Embroidery

My Initial Interest in Embroidery

I remember needlework classes in elementary school, when I had great difficulty making a neat row of red stitches on white cloth. The realization that I was no good at it resulted in a dislike of sewing, and it took the birth of my first child for me to overcome this aversion. I sewed my son's baby clothes by hand, but the plain white garment seemed a bit clinical so I decided to add a small embroidery of flowers. Through this I was able to grasp the true meaning of motherhood, while simultaneously discovering that I enjoyed this world of color that allowed me to express what I felt in my heart.

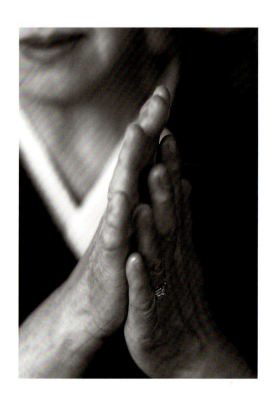

Looking back, I realize that my image of motherhood was largely based on the impressions I received from watching my own mother when I was a child. My mother was often to be seen sitting under a small light sewing a kimono; with four children to raise, my parents could hardly be described as rich and new kimono or kimono and obi with lots of embroidery were not luxuries that could be indulged in often. My mother had been something of an intellectual in her youth and had enjoyed reading books, looking at paintings, and dressing fashionably, but after she married and had children her social life was limited to PTA meetings for her children. She would always dress up to go out, but as she was not well off she would unpick her old kimono, then wash and re-dye them before sewing them back together again, adding lace flowers with silver thread or using other methods to create the kind of clothes she wanted to wear.

In other words, it could be said that my mother laid the groundwork for me to enter the world of embroidery. Before I realized it, I found myself doing exactly the same as she had done, and finding pleasure in the same things. After my son entered kindergarten, I was forever wondering what alterations I could make to my kimono to wear to the PTA meeting. I liked kimono a lot, but I could hardly buy a new kimono and obi every time I attended one of the meetings. Naturally there were economic reasons for this, but I also discovered that through embroidery I could achieve self-expression by working on my favorite kimono, and this proved to be the ideal form of creativity for me.

French Embroidery

I thus first took up French embroidery in order to create something for my child. The advantage of French embroidery is that it uses cotton fabric as a base, so it can be washed when soiled, making it ideally suited to children's clothes and various small items or interior decorations.

I began attending French embroidery classes in 1967, studying under Takiko Moriyama. Before I started my lessons with her, I had been extremely interested in embroidery and had learned a lot from books, enabling me to create all kinds of things. Even though I had managed to master a certain number of embroidery techniques, however, I could not find the kind of designs and color sense that I was searching for. Just as I was on the verge of giving up, I came across Ms. Moriyama's work. I think what makes her work so attractive is that her designs contain a romantic vision while her colors are crisp and clear.

For two years I took classes with her for two hours a week. In the beginning I learned how to create floral patterns through simple lines. Although I had already learned a variety of embroidery techniques, by doing these patterns I realized afresh just how difficult it can be to create a natural line through embroidery. I think it takes about twenty hours to become proficient at embroidering lines and about twice that long to fill an area with embroidery. As I gradually mastered the various techniques, I was able to enjoy the creativity of using my own coloring and designs as I decorated various small items and even produced framed pictures.

The author twisting thread before starting work.

From French Embroidery to Japanese Embroidery

One day I came across two Nō costumes in a museum. One was decorated with flowers such as narcissi and chrysanthemums embroidered in distinct colors on an indigo base, and I remember being amazed by the skill of its composition and coloring. The other was covered in an embroidered design of birds and cherry blossoms on a red base, and this impressed me to such a degree that I remained rooted in front of it, unable to move on for some time. I was able to understand each stitch that had been made, and I felt that I could almost hear the rhythm of the embroiderer's pulse. Enchanted by these traditional Nō costumes, I decided to make a kimono and obi decorated with traditional Japanese motifs for my niece's thirteenth birthday. From around this time I became fascinated by the designs on Nō costumes and antique kimono, and enjoyed thinking about how to combine the characteristics of various fabrics with different motifs. That was when I made up my mind to take the next step in my study of embroidery and learn how to recreate these traditional motifs accurately. It was the equivalent of an art student deciding to copy old masters in order to learn from them.

Having decided to take up the study of Japanese embroidery seriously, in 1973 I asked Masaaki Niwa to teach me. In those days, the only way to study Japanese embroidery was through classes in a limited number of universities, but as a housewife with

a young child this was impossible for me, and I was forced to abandon the idea. However, I had heard that Mr. Niwa was very understanding towards people with a real love for the subject, and so I asked a mutual acquaintance to introduce me to him.

When I first met him on his doorstep, he said bluntly, "I will not teach you if you are only in it for the money," and gave me a fierce look. He was a most genuine person, devoted to expanding the possibilities of embroidery as a form of artistic expression and was recognized as the leading figure in the field. In his opinion, it was impossible to create an artistic work in embroidery without a solid foundation in the necessary skills. He said, "Naturally it is important to know what you wish to express, but it is equally important to have the ability to create what you want, so technical training in embroidery must not be treated lightly." I remember one time he had gone to great lengths to teach me a particular stitch, but I did not exert myself and the work I produced was shoddy. As a result, he pointed out my failings and gave me a dressing down in front of the entire class.

I studied under Mr. Niwa for about three hours a week until 1977. I had already studied French embroidery, and as the basic techniques are quite similar I made fast progress. The main difference between the two is that in Japanese embroidery every stitch has to be made most delicately, so it takes much longer and requires much greater patience.

One of the simplest techniques in Japanese embroidery is *komadori* (coaching), which is used to create outlines, but it takes about thirty hours of practice to be able to make natural looking lines using this method. A much harder technique is that of creating gradation through *sashinui* (shading stitch), and this can take three or four times as long to master. In the beginning I practiced filling in a design of an origami crane with an embroidery technique called *kiriosae* (short holding stitch), using fine threads of the same color in order to prevent them appearing to stand out, but I remember it being very difficult and having great trouble in making the embroidered area appear even and natural.

When it came to creating pieces, Mr. Niwa offered detailed instruction on the coloring and technique. I once embroidered a kimono with a scene based on *The Tale of Genji*, having discussed the project with him from the design level. On completion, I was delighted to have been able to produce something that utilized the delicate expressive techniques that can only be achieved through Japanese embroidery; I felt it was a valuable experience.

Learning Japanese embroidery from Mr. Niwa, I realized the importance of studying art and design in order to produce better works. However, with a family to look after, I could ill afford the time or money necessary to attend another school so I began to visit secondhand bookstores in search of books on Japanese art and textile design. I devoted as much time as I could to the study of traditional motifs, while also making an effort to come into contact with works of art whenever I could. There are various different types of design, so I would select those that would be easy to apply to an obi, those that would be effective if applied to a kimono; I chose traditional

motifs that I particularly liked, adapting them to embroidery or even redesigning them. I did not have a photocopier in those days and so I would draw the designs repeatedly on graph paper until I was satisfied with the result. After that I would consider the relationship between the design, coloring, and embroidery technique, producing the same design in a variety of colors then using them to experiment with every embroidery technique I knew.

Mr. Niwa would always choose the colors I used, but I was eager to test my own ability by creating a work for which I had chosen the colors myself. Of course, there was still a lot that I could learn from Mr. Niwa, but the desire to test myself came out on top, so after discussing it with him I decided to work on my own. During the years I studied under him, I learned not only the techniques of Japanese embroidery, but also the way in which designs and motifs are constructed and the rules that traditional patterns follow; in other words he provided me with a foundation upon which to base my future creative work.

The Source of my Inspiration

With regard to ideas for motifs or methods of expression, I am inspired by things I see in my daily life as well as various other sources. In textile design, the embroideries dating back to the seventh or eighth centuries, or the Nō costumes and kimono developed from the Momoyama period (1573–1603) onwards are very interesting. In other fields there is the art of the late sixteenth to early seventeenth centuries, particularly that of the Rinpa school, but above all else is the literary classic *Genji monogatari* ("The Tale of Genji") and distinguished works of modern literature. I have already covered ancient embroidery, Nō costumes, and early kimono in the "History of Japanese Embroidery" section, so now I would like to write about my thoughts on the Rinpa school and *The Tale of Genji*.

The Rinpa School

If you asked a Japanese person what they like best in Japanese art, I believe the majority would say it was the work of the Rinpa school. From screens to fans to lacquerware to kimono, the Rinpa school embodies all the best aspects of Japanese art, with its sophisticated design, sense of style, freshness of color, and a uniquely Japanese aesthetic of simple but elegant rusticity.

The Rinpa is not a "school" in the accepted meaning of the term, since the artists were not connected through a master-apprentice relationship, and indeed their styles of work vary tremendously. Nevertheless, they respected their forerunners and fellow artists, learning from their style. For approximately two centuries, from Hon'ami Kōetsu (1558–1637) to Suzuki Kiitsu (1796–1858), the school produced vibrant works that are still loved by the Japanese today.

All of the artists of the Rinpa school were individualistic in their work, but one thing they held in common was the fact that they looked for their subjects in classical

Both flowers have been embroidered using *sashinui* (shading stitch): the one on the right is in three stages, and the one on the left is in two.

literature or seasonal flowers, producing elegant, delicate, evocative works. They did not hesitate to use large quantities of expensive mineral pigments, combining them with gold or silver foil to create gorgeous works that exploit the decorative effects of Japanese art to the full. Every time I see a work by Tawaraya Sōtatsu (fl. 1600–43) or Ogata Kōrin (1658–1716) I am amazed, not only by the way they depict flowers, but also their overall composition and the visual effects they achieve through the use of color. The designs on their decorated screens and kimono are more than merely textbooks to me, they are my bible. I could no longer tell you which work I learned from, which provided me with some reference, or which inspired me; in the same way that the food I eat becomes the blood and flesh of my body, so their works have become an integral part of my embroidery.

If I were forced to make a choice, I would have to say that of all the Rinpa artists, Kōrin is the one that I respect the most. He was active as an artist for about twenty years from the end of the seventeenth century, and although this is not very long,

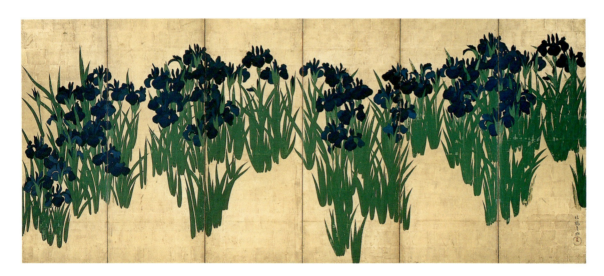

Kakitsubata
by Ogata Kōrin
Edo period
Nezu Institute of Arts, Tokyo

the works he produced during this period have become characteristic of the whole Rinpa school. His most famous are the *Kakitsubata* ("Irises") screen, the *Kōhakubai* ("Red and White Plum Trees") screen, and a lacquered box decorated with a design of irises. In addition to these being outstanding works in their own right, his style of expression and composition are quite different from anything that went before. He used revolutionary new techniques, while the motifs he created and his way of expressing them could be applied equally to paintings, crafts, or textiles, with the result that he was to have an immeasurable influence on the future of Japanese art. His was a presence that transcended time. An example of his originality can be seen in the "Red and White Plum Trees" screen, in which an abstract pattern of flowing water in the center has been combined with realistic renditions of two plum trees, but even using these two totally different styles of painting within a single work he manages to create an overall result of fresh harmony rather than a feeling

of imbalance. His pictures of irises are a perfect example of the influence he was to have on later artists, as his method of illustrating groups of iris plants scattered in a rhythmical pattern can be found today in a wide variety of genres.

The Tale of Genji

The Tale of Genji was written by the court lady Murasaki Shikibu at the beginning of the eleventh century. When the novelist Yasunari Kawabata (1899–1972) was awarded the Nobel Prize in Literature, he gave a lecture entitled "Japan, the Beautiful, and Myself," in which he said, "*The Tale of Genji* in particular is the highest pinnacle of Japanese literature. Even down to our day there has not been a piece of fiction to compare with it. That such a modern work should have been written in the eleventh century is a miracle, and as a miracle the work is widely known abroad . . . For centuries after it was written, fascination with the *Genji* persisted, and imitations and

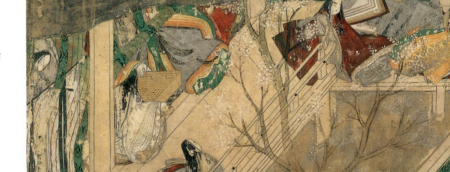

Genji monogatari emaki
Heian Period, 12th century
Tokugawa Museum, Aichi prefecture

reworkings did homage to it. The *Genji* was a wide and deep source of nourishment for poetry, of course, and for the fine arts and handicrafts as well, and even for landscape gardening." [Excerpt from the translation by E. Seidensticker.]

I do not know of any other description of *The Tale of Genji* that sums up its brilliance so succinctly, and it is quite true that it provides an inexhaustible source of nourishment for my work. As with all works of literature that have become recognized as classics, readers are able to open its pages today and find passages that relate to their personal problems and to experience themselves through it. Having been greatly moved by it myself, I decided to use all fifty-four of its chapters as subjects for obi, kimono, curtains, and screens, and after more than ten years on the task, I have finally succeeded.

I first created a work based on *The Tale of Genji* when I was studying under Mr. Niwa. Four years had passed since starting embroidery, and I wanted to create

something special on a formal black kimono. I had long held a secret desire to do something based on *The Tale of Genji*, and when I suggested this to Mr. Niwa he showed me a picture scroll of the work. After much enjoyable hesitation, I finally settled on a scene from chapter forty-five, entitled "The Bridge Maiden," in which the gallant young Kaoru first meets Ōigimi. The eldest of three sisters (Ōigimi, Naka no Kimi, and their stepsister Ukifune), Ōigimi dies still refusing Kaoru's advances, but the romantic relationships between these three sisters, Kaoru, and Prince Genji's grandson Niou are most complicated, and introduce a strong element of tragedy into the story. This is what made the greatest impression on me when I read it.

The author at work.

The Tale of Genji is generally thought to be simply a story about an extremely handsome man, Prince Genji, and the various love affairs he enjoys, but in actual fact it concerns the joys and sorrows that affect Genji and those that surround him. It is a long novel that contains love, adultery, elopement, kidnapping and imprisonment, bullying, depression, anorexia, amnesia, political intrigue, and factional strife—in other words, if the background were changed, it could have been written about present-day Japan. The fact that we can sympathize with and be moved by the story even today, a thousand years after it was written, demonstrates that it makes no difference when the story was set, and the timeless human drama that it presents attests to the author's powers of perception and skill at writing.

Glossary

ajiroguminui wicker braid stitch
ajirokakenui wicker effect
asanohanui flax leaf effect
bokashinui gradation effect
ganbishinui arrow effect
hitta shibori square tie-dye fabric
hittanui square tie-dye effect
jibiki weft layer stitch
jibiki bokashi weft-layer gradation
jūji kuminui cross-tacking
kaeshinui backstitch
katsurayori twisted vine effect

kiriosae short holding stitch
kiriosae bokashi short holding stitch gradation
komadori coaching
matsuinui running stitch
moyōnui pattern stitch
naka yuwaenui single central braid stitch
nuikiri angled stitch
orinui woven design effect
sagaranui French knots
sashinui shading stitch
shibori tie-dye effect
shibori zome tie-dye fabric

shioze silk taffeta
suganui skipping stitch
tatebiki vertical stitch
tatejibiki vertical weft layer stitch
tatewakunui wavy stripe effect
tazunanui cord effect
tsuzure-ori figured brocade
warinui symmetrical stitch
watashinui tacking stitch
yokojibiki horizontal weft layer stitch

Technique

Saigyō zakura

The yellow sections represent the cherry tree in Saigyō's garden, while the blue sections show the spirit of the cherry tree who he meets in his dream. The fabric was dyed in a parti-colored pattern reminiscent of Nō robes, and various contrivances were used in the color and methods of embroidery.

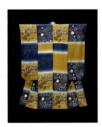

Aru onna

The heavy fabric with a woven design of flowers in gold thread was dyed mauve, fading to a paler shade at the bottom. A profusion of autumnal flowers

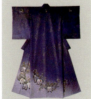

and baskets of wisteria were then applied through embroidery, creating a gorgeous yet lonely image.

Shunkinshō

Flowers of the four seasons were embroidered within the outlines of the bamboo leaves, their bright colors stressing the minuteness of detail. The plum blossoms were expressed through monotone gradations that create a sense of depth and stress their boldness.

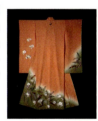

Onna Sannomiya

When embroidering the landscape, fine threads and delicate stitches were used to create minute motifs. The *jibiki* technique was used for the rabbits, while the pine trees were portrayed through outline alone, and the peonies through different shades of glossy thread. The *jibiki* stitch was used again to express the maple leaves, with their veins picked out in gold or silver threads.

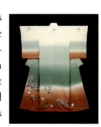

Sakura no mai

The flowing water pattern on the shiny mauve damask fabric creates a richness in the garment. The branches of the cherry tree and the outlines of the fans were applied in the *nuikiri* stitch to make the pattern stand out.

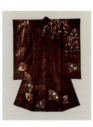

Yūgiri

Circular floral designs representing the passage of time were applied in restrained colors to make them merge with the gradated red, golden-brown, and blue areas created through ombre dyeing.

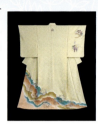

Hana no en

Two kinds of embroidery were used to depict the cherry blossom: *tatejibiki* to create a five-petalled blossom; and gold thread in the center and *sagaranui* to produce different tones. The mountain and flowing water were applied using *nuikiri* to create an image of the passing of time.

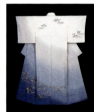

Sakaki

The wisteria blossom depicted in achromatic tones expresses the fact that Fujitsubo became a nun. Gold thread was added using *suganui* to suggest a feeling of nobility.

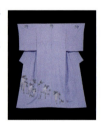

Murasaki

The name Murasaki means "purple," of which there are numerous different shades. In order to express the girl's youth I dyed this kimono in a shade that is almost pink and added a gradation. Embroidery for the outlines and illustrations on the covers of her picture books are important. I added a hemp-leaf pattern and seasonal flowers, while the mist representing the passage of time was expressed using gold and silver threads in *matsuinui*.

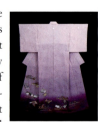

Tsuru maru

The crowns of the birds were applied using *sagaranui*, and the bodies using *tatebiki* in filoselle with *komadori* in gold thread applied over it. *Nuikiri* was used for the wings, with *komadori* in gold thread applied to the center.

Agemaki and Sawarabi

I used *sashinui* in the peonies to create a gradation, and *nuikiri* in a thick thread for the chrysanthemums, taking care to make each petal stand out. Ōigimi's chrysanthemums were filled using non-twisted thread then reworked using *komadori* in gold thread. *Hittanui* was used for the plum blossom, and *asanohanui* for the orange tree.

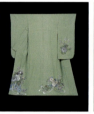 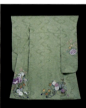

Tagasode roman

The outline of the motifs around the hem were embroidered using threads in the same color as the original dyed patterns in *nuikiri*, then the edges of these were picked out using gold thread to create a gorgeous effect. The designs on the fans, including chrysanthemums, hollyhocks, and bamboo, were embroidered using *nuikiri* and *komadori* to make them stand out clearly.

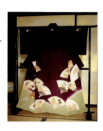

Hanagatami

A gold-wefted fabric was dyed in a staggered checkered design often used in Nō costumes, blue for the man and vermillion for the woman, on a cream background. Onto this was added cherry blossom and maple leaves, plants that are widely separated by the seasons but here sharing the same flower basket to symbolize the characters in the story. The butterflies act as guides to bring the two together. The basket was expressed using *ajirokakenui*.

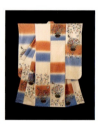

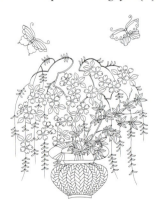

Nadeshiko

The flowers were applied using *sashinui* with the leaves in *nuikiri*. The waves are in *matsuinui*, while the crests were applied using gold and silver threads in *komadori*.

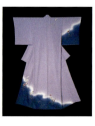

Kotohogi ni tsudoite

The head of the crane was depicted using *sagaranui*, with the wings in *nuikiri*. The shell of the turtle was expressed using *jibiki* and *komadori*, the tail being added with gold and silver threads in *matsuinui*. Different combinations of color and stitch were used for four different types of pine tree to add variety to the design. The bamboo leaves are in *nuikiri* using untwisted thread, with the veins picked out in *matsuinui*. Three types of stitch were used for the plum blossoms: *sashinui*, *hittanui*, and *komadori*.

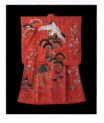

Gunkaku

Although the motifs are all cranes, some were depicted using *nuikiri*, some using *suganui* in gold, and others in outline using *komadori* in order to create variety in the work.

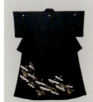

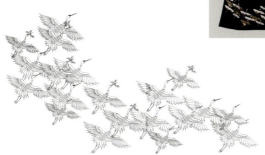

Amagigoe

The fabric was dyed dark green to represent Mt. Amagi, and then blossoms of the mountain cherry tree were applied in *sashinui* using two colors to express their fluffy softness. The gold threads applied to the leaves using *komadori* add a sharpness to the image and express the resoluteness of a woman's heart.

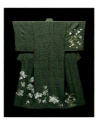

Koki

Jibiki bokashi was used for the pine trees on the kimono to create delicate changes in color. On the obi, the cords of the fans were depicted using *nuikiri*; for the upper fan only *orinui* was used, while the outline of the phoenix fan is in *komadori* in twisted silver thread.

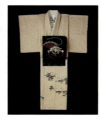

Autumnal Flowers

The autumnal flowers on the kimono are quite slender so they were depicted using thin, twisted thread in *nuikiri* and *matsuinui*. The cosmos flowers on the obi are in *sashinui*, while the leaves were expressed using *nuikiri*.

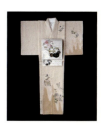

Umegae

The clouds on the kimono were applied using only *nuikiri* and *suganui* in gold, silver, and twisted monotone threads. The scrolls on the obi were embroidered using *orinui* and *ganbishinui*.

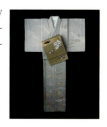

Spider Chrysanthemums

The white nippon daisies on the obi were applied using *nuikiri* in a thickish twisted thread to give them volume and to create a serene composition. The kimono gradates from black to grey and was decorated with a scattering of spider chrysanthemums to create a feeling of movement, these being applied using *nuikiri* in thin, twisted thread. The leaves were expressed using only two types of stitch: *matsuinui* in twisted thread and *suganui* in gold thread.

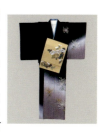

Cherry Blossoms

A wide variety of cherry blossom designs were applied to the kimono using various embroidery techniques, such as *hittanui*, *suganui*, and *matsuinui*, to create interest in the design. On the obi, the impression of cherry blossoms floating on a stream was achieved by using gold and silver threads in *matsuinui* on a lustrous black silk fabric. It was finished off using three techniques: *jibiki*, then *tatejibiki*, and *matsuinui* for the outlines.

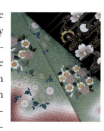

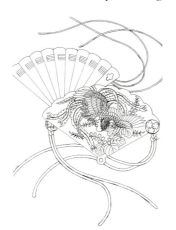

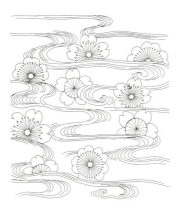

Spring Flowers

Wild flowers may be small, but they have beautifully balanced stamens and pistils. These were expressed using delicate *matsuinui* and *nuikiri* in thin silk or gold threads.

Sakura roman

I used *sashinui* for the cherry blossoms, *nuikiri* for the buds and leaves, and *matsuinui* for the stems and mist.

Tamakazura

The clouds were outlined using *nuikiri* in twisted thread, with a gradation added using silver thread in *suganui*. The cord was expressed using twisted thread in *nuikiri* and the tassel on the end in *sagaranui*.

Azumaya

The outlines of the shell buckets and pine trees on the kimono were picked out using silver or gold thread in *komadori* or twisted thread in *matsuinui*, causing the colorful motifs to stand out. The cords were portrayed using a thickish twisted thread in *nuikiri*, stressing the flow of the pattern and creating a more pronounced three-dimensional effect. On the obi, the three cords were applied using thickish, twisted thread in *nuikiri* to create a feeling of volume. There are two fans, one representing the landscape of Uji through the depiction of wild pinks in *sashinui* and chrysanthemums in *nuikiri*, with the outlines picked out using *matsuinui*. The other fan was filled using only *orinui* and a form of *moyōnui*, with the outline picked out using gold and silver *komadori*.

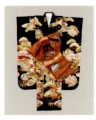

Takara zukushi

This particular assorted treasures design contains various cords, all embroidered using *nuikiri*. The majority of motifs are very small, and were applied using *komadori* in gold and silver threads over *jibiki*, giving the treasures a rich finish.

Rabbits and Seasonal Flowers

The rabbits on the kimono were applied using *jibiki* and *nuikiri*, while their outlines were picked out using *komadori* in gold thread. Snowflake motif appliqués were cut out of *shibori zome* fabric and attached to the obi, with their outlines picked out using *komadori* in gold thread. The cherry blossoms were applied using *sashinui*.

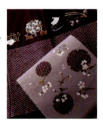

Suma and *Minori*

Three types of embroidery were used on the *Minori* obi: *hittanui*, *sashinui*, and *jibiki bokashi* on gold tapestry-weave fabric. For the *Suma* kimono I used *jibiki* and *komadori* for the wheels, and *nuikiri* for the waves.

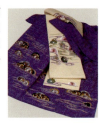

Kagerō and *Asagao*

Three methods were used to express the bush clover leaves on the kimono: *suganui* in gold thread; *matsuinui* in twisted thread; and appliqués of *hitta shibori*. The wings of the mayflies were expressed using *nuikiri* in non-twisted thread and fine *matsuinui*. The morning glory on the obi were created in *sashinui*.

Double-Flowered Cherry Blossom

I expressed the petals of the flower using ten gradations of color in *sashinui*. For the leaves I used non-twisted thread in *jibiki* with the veins picked out using gold thread in *komadori*.

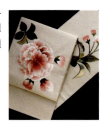

Circular Floral Motifs

The center of the daffodil was filled using non-twisted threads with the outline picked out using *komadori* in gold thread. The flower was depicted using *yokojibiki* in twisted thread. The leaves had veins added using *nuikiri* in gold thread. The nandina berries were applied one by one using *jibiki*, while *warinui* was used for the leaves, with the centers picked out in gold thread using *nuikiri*.

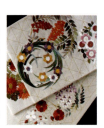

Cherry Blossoms

The flower buds were expressed using *nuikiri*. The leaves were applied using non-twisted thread in *yokojibiki*, then *komadori* in gold thread. I used *sashinui* for the front of the flowers, and *tatejibiki* for the rear.

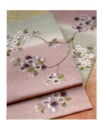

Harukaze and Nioi zakura

The boats in *Harukaze* were expressed using twisted thread in *suganui*, while *sashinui* was used for the cherry blossom. The moon in *Nioi zakura* was created in gold thread using *suganui*, and the black flowers expressed with *hittanui*.

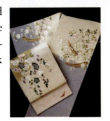

Double-Flowered Camellia

The flower was depicted using *sashinui*, while two different techniques were employed for the leaves: *suganui* and *nuikiri* in gold and silver threads, and *jibiki* and *nuikiri* for the other.

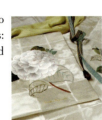

Bamboo and Camellias

The snow on the bamboo leaves was expressed using silver thread in *suganui*, while the snow on the camellias was depicted using white twisted thread in *jibiki*. The bamboo leaves were embroidered using *nuikiri* with gradation.

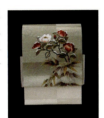

Wisteria and Irises

The outlines of the wisteria and iris flowers were applied to silver-white fabric using *komadori* in gold and silver thread, then filled in with *yokojibiki*, the leaves of both being applied using *nuikiri*.

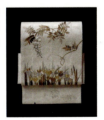

Irises and Fireflies

The light of the fireflies was expressed using gold thread in *suganui*, with the bamboo fence in *matsuinui*.

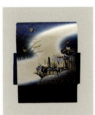

Camellia

The balance between the *jibiki* in the lower part of the flower and the *sashinui* in the upper part is most important. The outline and veins of the leaves were expressed in *nuikiri*, and the addition of the gold thread at the tips creates a feeling of light. The center of the flower was portrayed using gold thread in *watashinui* and twisted thread in *matsuinui*.

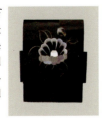

Haruka zakura, Kokoro zakura, and Utsuroi zakura

When embroidering cherry blossoms, the method used depends on the blossom's size and shape. For *Haruka zakura* I used *hittanui* and *jibiki* to fill large areas of blossom. In *Kokoro zakura* each petal was embroidered separately using fine threads. In *Utsuroi zakura* the area of each flower was filled in and then the stamen added using *sagaranui*.

Usuzumi zakura and Kuon zakura

For *Usuzumi zakura* I used *hittanui* and *bokashinui* to fill in the large area of the blossoms. In *Kuon zakura*, each petal was embroidered separately using fine thread.

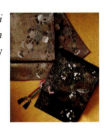

Ryūrei

Tatejibiki was used for the cherry blossoms, while the waves and birds' feathers are in *nuikiri*. Before embroidering the cherry blossoms, I applied two or three thick threads at right angles to the *nuikiri* of the blossoms in order to create more volume. All the motifs depicted through lines were applied using thick thread to create an impression of bulk.

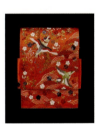

Aoi no Ue

The hollyhock leaves were depicted using *nuikiri*, and the cord in *naka yuwaenui*. The pattern on the cloth hanging was depicted in *jūji kuminui* for the center band, and *tatewakunui* for the floral pattern.

Usagi no dansu

I used *jibiki* and *kiriosae* for the bodies of the rabbits so that the light effect changes according the angle from which they are viewed. I used gold and silver threads for the snowflakes.

Hana yūzen

I used *sashinui* for the wisteria, and *nuikiri* and *komadori* in gold and silver threads for the chrysanthemums.

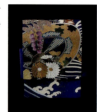

Coffered Ceiling

The lattice framework was applied using *yokojibiki* and *komadori* in gold thread. The pine trees were applied using *sashinui* and the clouds in *orinui*.

Assorted Treasures on Black

The treasure sack and straw raincoat were expressed using *jibiki* in non-twisted thread, then gold or twisted thread was applied over this in *komadori* or *matsuinui*.

Hat with Assorted Treasures

The hat cord was expressed using *nuikiri* in a relatively thick twisted thread in order to give it body. Outlines on the dyed *hitta shibori* patterns were picked out using *komadori* in thick gold thread.

Floral Appliqué

This obi is made from fabric used to make *hakama* (skirt trousers) for men, which is thick and difficult to embroider. In order to overcome this problem, the embroidery was done on thin silk fabric which was then cut out in a variety of shapes and appliquéd to the *hakama* fabric, creating a very feminine design.

Chrysanthemums

The leaves of the chrysanthemums were embroidered using *hittanui* to harmonize with the *hitta shibori* borders of the obi. The flowers were expressed using thickish twisted thread in *nuikiri*.

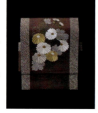

Yorokobi

The assorted treasures motifs are small, so I used *nuikiri* and *komadori*, and the cords are in *nuikiri*, with abundant use of gold and silver threads to make them stand out.

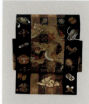

Birds and Cherry Blossoms, and Letter Scrolls

The bodies of the birds were portrayed using *sashinui* with *nuikiri* for the wings. For the cherry blossoms, *sashinui* were used on the fronts and *tatejibiki* on the backs of the petals. On the letter scrolls, *naka yuwaenui*, *ajiroguminui*, and *tazunanui* were used for the cords. On the scroll case, *komadori* in gold thread was used to create an arabesque pattern that was filled in using *sagaranui*.

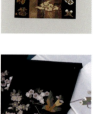

Fan Appliqué

The dew on the autumnal grasses was expressed using *sagaranui* in twisted thread and *jibiki* in silver thread. The outlines of the fans are in *nuikiri*, the handles in the *orinui* effect, and the cords in *naka yuwaenui*.

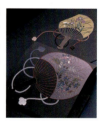

Shiigamoto

In this work I created a beautiful landscape on elegant gold woven fabric. Peonies were depicted using *sashinui* to create a gradation from white to grey. The grey shading of the pine trees was applied using *jibiki* with gold and silver threads added in

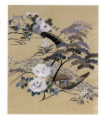

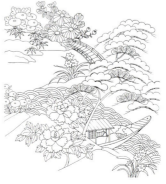

komadori. The white and grey of the chrysanthemums are in *nuikiri*. The bridge and boat were portrayed using brown and gold threads in *jibiki* and *suganui*. My object was to produce a feeling of tranquility, avoiding too much varied color and working in monotones.

Shell Bucket and Family Crests

The cloud design on the shell bucket is expressed using *orinui*, while *naka yuwaenui* has been used for the cord. The circular borders around the family crests were either completely filled using *komadori* in fine gold thread, or the outline only picked out in *komadori*.

Peonies and Butterflies

Twelve different steps using different tones and thicknesses of thread were used in *sashinui* to express the flowers. The leaves were portrayed using *katsurayori* thread to create a *kiriosae bokashi* effect.

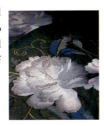

Hanachirusato

The mandarin oranges were expressed using *jibiki* and *asanohanui*.

Makibashira

One kimono sleeve was embroidered using *hittanui* while the other was decorated with bellflowers, wild pinks, and other autumnal plants using *sashinui*. The cords were applied in *ajiroguminui*.

Inochi no inori

I used three lengths of *shioze* obi fabric, which is only woven in thirty-centimeter widths, and dyed them in a gradation from blue to green in order to create a single, cohesive work. As the cherry blossoms are scattered over the entire motif, variety had to be introduced to avoid the color or embroidery techniques becoming too uniform.

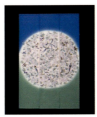

Hana utsuroi

Two types of butterfly were expressed, those using *shibori* appliqués and those with flowers representing the four seasons embroidered onto their wings. The base fabric was dyed in four colors to represent the different seasons, and flowers appropriate to each season were applied using embroidery.

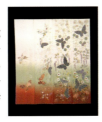

Kamon

The framework was created using gold fabric tape, care being taken to balance it with the luster of the silken threads. The main challenge was to achieve harmony in the overall coordination of color and shape. Various types of embroidery were used, but particular care was taken to vary the colors and types of stitch in order to create varied nuances. Even the same design can look quite different depending on the colors and type of embroidery used. The line motifs are mainly in *suganui* or *matsuinui*, the balance of the gold or silver threads with the monotones setting off the designs.

Daffodils [details]

The positive daffodils were expressed in gorgeous color, the white areas using *yokojibiki* with the outlines in silver thread *komadori*. For the leaves, *nuikiri* was used in deep green, with the veins picked out using *komadori* in gold thread. The negative daffodils were expressed more subtly, in outline alone, using *nuikiri* in silver thread. The leaves were expressed through outline and veins, using gradations of grey in *nuikiri*.

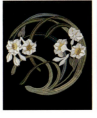 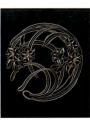

Cotton Rose [detail]

The summer-blooming cotton rose is a delicate flower that sways in the slightest breeze. To express the ephemerality of its one-day existence I used *sashinui*, adding gold thread in *komadori* for the filaments and *sagaranui* for the anthers to make them seem as though they are trembling in a breeze. The leaves were expressed using a lustrous non-twisted thread in *yokojibiki* with the veins picked out using silver thread in *komadori*.

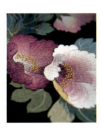

Kunpū

The wisteria blossoms were depicted in *sashinui* and *nuikiri*, the leaves in *warinui*, and the vine in *nuikiri*. *Jibiki* was used for the iris flowers, with the edges picked out in *komadori* in gold and silver twisted threads. Two types of embroidery were used on the leaves, the gradation achieved in *nuikiri* with *matsuinui* for the outlines.

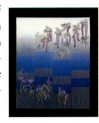

Matsukaze

Interest was created in the pine tree motifs by using three different embroidery techniques: *jibiki*, *nuikiri*, and *komadori*. The balance with the woven pattern of the obi fabric is most important.

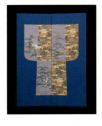

109

Acknowledgments

The publisher would like to thank the
following for their collaboration:

Chūgūji Temple (Nara prefecture); page 90
Hayashibara Museum of Art; page 93 (top)
Ishikawa Nanao Art Museum; page 92
Japan Broadcast Publishing Co. Ltd.; pages 4, 5, 8–9, 14–15, 20, 26–27,
 36, 43, 47, 48, 54–55, 56–57 (left), 58–59, 64–65
Nezu Institute of Fine Arts; page 100
Sainenji Temple (Ishikawa prefecture); page 92
Sekai Bunka Publishing Inc.; pages 10, 11, 12, 13
The Tokugawa Art Museum; pages 91, 101
Tokyo National Museum; pages 93, 94

PHOTO CREDITS

Benridō; page 90
Maeda Shinzō, Photo Library Tankei; pages 34–35
Matsukawa Yutaka, Kodansha; pages 2–3, 6–7, 17, 18–19, 22–23,
 24–25, 31, 32–33, 49, 60–61, 68, 69 (left top, right top), 70 (bottom), 71
 (bottom), 82–83, 89
TNM Image Archives; pages 93, 94

The publisher would further like to thank
The Kusano Studio, Kumiko Tomioka, and Kodansha Editorial
for their help and collaboration.

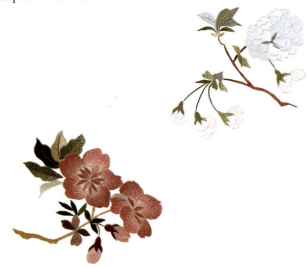

The process of embroidering this piece, shown on pages 1 and 53, is here completed.

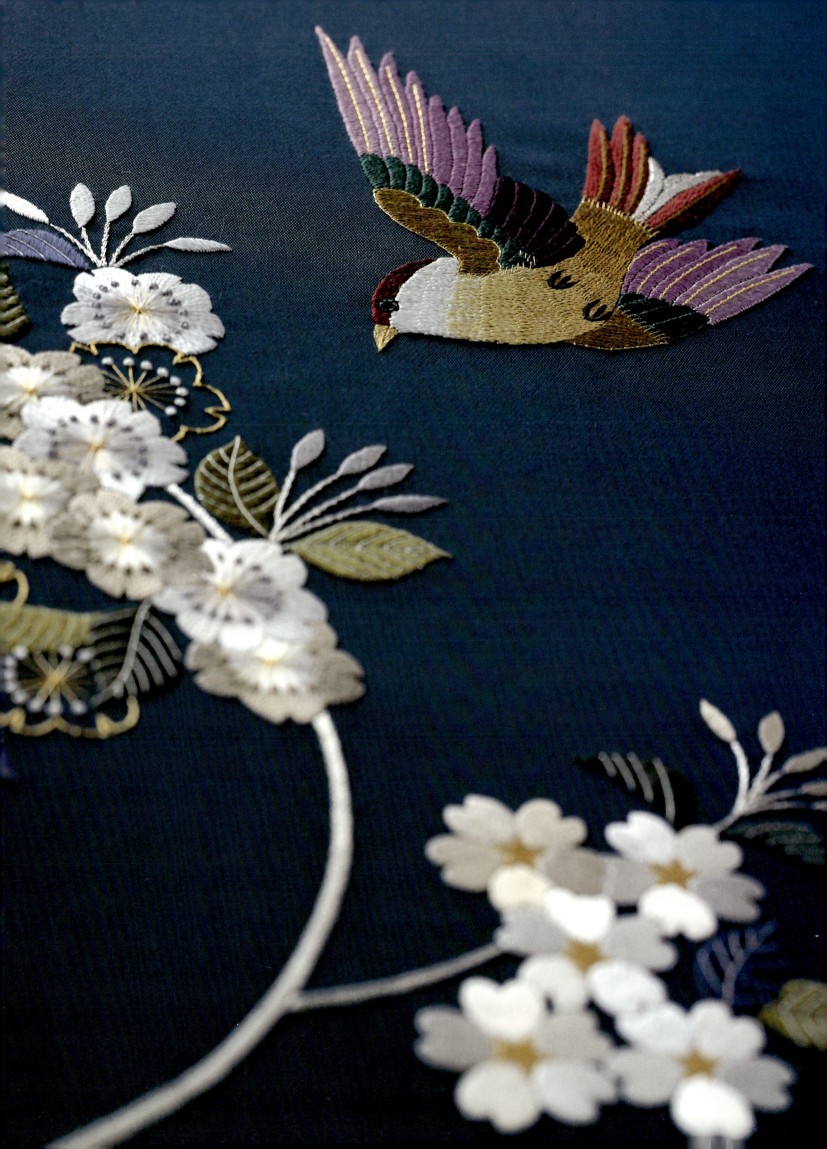

(英文版) 草乃しずか日本伝統刺繍
The Fine Art of Kimono Embroidery

2006年9月　第1刷発行
2007年10月　第2刷発行

著　者　草乃しずか
撮　影　筒井雅之
翻　訳　ギャビン・フルー
編集協力　ジニー・タプリー
　　　　　アトリエ草乃しずか・富岡久美子
　　　　　株式会社 講談社エディトリアル
発行者　富田 充
発行所　講談社インターナショナル株式会社
　　　　〒112-8652　東京都文京区音羽 1-17-14
　　　　電話　03-3944-6493（編集部）
　　　　　　　03-3944-6492（マーケティング部・業務部）
　　　　ホームページ　www.kodansha-intl.com

印刷・製本所　大日本印刷株式会社

落丁本、乱丁本は購入書店名を明記のうえ、講談社インターナショナル業務部宛にお送りください。送料小社負担にてお取替えいたします。なお、この本についてのお問い合わせは、編集部宛にお願いいたします。本書の無断複写（コピー）は著作権法上での例外を除き、禁じられています。

定価はカバーに表示してあります。

© 草乃しずか 2006
写真 © 筒井雅之 2006
Printed in Japan
ISBN 978-4-7700-3024-5